WATERCOLOR
FAIRIES

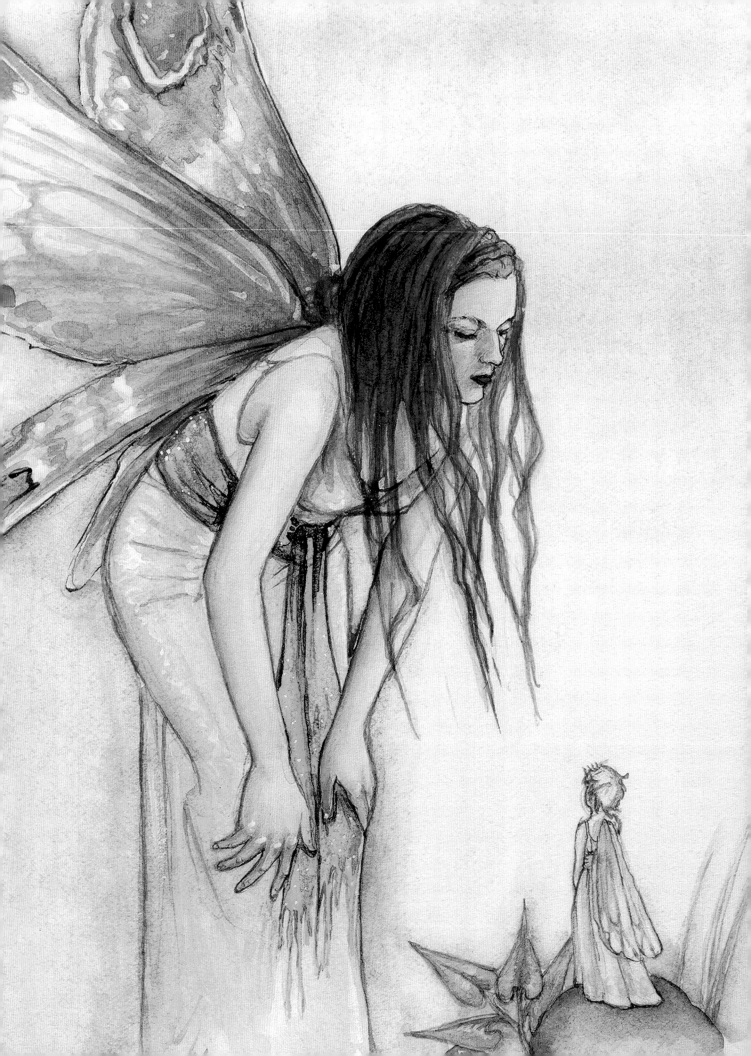

WATERCOLOR FAIRIES

A STEP-BY-STEP GUIDE TO CREATING THE FAIRY WORLD

DAVID RICHÉ
ANNA FRANKLIN

WATSON-GUPTILL PUBLICATIONS
NEW YORK

A QUARTO BOOK
Copyright © 2004 Quarto Inc.

First published in the United States in 2004 by
Watson-Guptill Publications, a division of
VNU Business Media, Inc.
770 Broadway
New York, NY 10003
www.watsonguptill.com

Library of Congress Catalog Card Number: 2004104323

ISBN 0-8230-5640-6

QUAR.WCF

Conceived, designed, and produced by
Quarto Publishing plc
The Old Brewery
6 Blundell Street
London N7 9BH

Project editors: Nadia Naqib, Claire Wedderburn-Maxwell
Art editor/designer: Jill Mumford
Picture researcher: Claudia Tate
Copy editor: Hazel Harrison
Assistant art director: Penny Cobb
Editorial Assistants: Jocelyn Guttery, Kate Martin
Illustrators: see page 127

Art director: Moira Clinch
Publisher: Piers Spence

Manufactured by Universal Graphic, Singapore
Printed by Star Standard Industries (pte) Ltd., Singapore

1 2 3 4 5 6 7 8 9 / 12 11 10 09 08 07 06 05 04

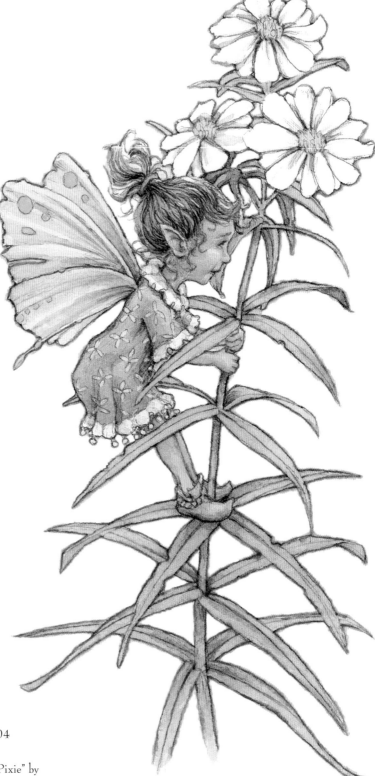

Page 1 "Constellation" by Myrea Pettit, page 2 "Study for a Pixie" by
Julie Baroh, page 4 "Flower Fairy" by James Browne

For Aimee with love from the Fairies

"I want to expand everyone's awareness of what fairies are about, for
them to have access to the sacredness and a personal spiritual journey."
Brian Froud

CONTENTS

Introduction

Did you wonder why you picked up this book—what made you do it? Could it have been the title, the cover image, a recommendation from a friend, or just simple curiosity? Or might you have been guided by an unseen force that seemed to urge you to visit another world? Deep in our psyches most of us have a sense that magic can happen and that the veil between two worlds can be lifted, just as it sometimes is in dreams.

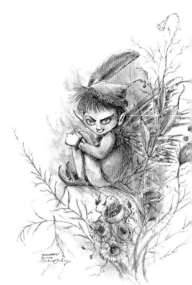

EXPLORING THE ENERGY OF THE WORLD OF FAIRIES

Some people may wonder about the choice of fairies as a subject, when there are so many more accessible ones at hand. One answer is that painting fairies gives us a chance to explore our creative side and stretch our imagination in a way that mundane, everyday subjects do not. Another is the simple wish to escape from dull reality and make a connection to a spiritual world. It is no coincidence that the great fairy art movement began in Victorian England during the years of the industrial revolution, when life was tough for many, and the countryside was changing beyond recognition. As factories went up, belching smoke and dirt, and large tracts of land disappeared under bricks and mortar, the Victorians fell in love with fairies—not only in art but also in books and plays. These spirits of nature seemed to symbolize a vanishing way of

ZACHARY ✶ PAULINA STUCKEY (above) This little fellow is full of mischief. Pen and ink, watercolor pencils and washes were used to build up the picture, but the area around the fairy was treated with minimal color to focus attention on the figure.

MUSIC OF THE LAND ✶ VIRGINIA LEE (left) In this light pencil sketch the fairy, playing her lyre, seems to be rising out of the land itself, at one with nature.

HIGH POINT ✶ JAMES BROWNE (right) The artist painted this of his muse and wife after being inspired by a walk in the wood, gazing up at the trees. He created this to capture the moment.

life, and to reconnect the viewer or reader to the beauty and mystery of nature.

There are certain parallels to be found in our own age, where—despite huge advancements in technology, transportation, plus a better quality of life in general—increasing expectations and the pressures of a modern-day society have meant that more and more people suffer from anxiety and stress, which may in part account for the ever-increasing tide of books, films, animation, and computer games dealing with fantasy and the supernatural. It could almost be said that the fairies have come among us again, inviting us out to play.

VISUALIZING THE FAIRY WORLD

Another frequently asked question is, "How can you paint fairies when you can't see them?" There are plenty of descriptions of all the various types of fairy in folklore and mythology, and to make this book as useful as possible, our authors have drawn on these old sources to compile a comprehensive directory of fairies. Here you will find details about what each type of fairy looks like, what they wear, where they live, and what their special tasks are, helping you to set the scene for your personal depictions.

THE MISCHIEVOUS PIXIE ✱ JULIE BAROH This artist particularly loves painting pixies, elves, and the smaller fairies. She tries to show their individual "funny personalities"—lovable, cheeky, and full of character.

Once you have an idea of your fairy's character, painting it is no more difficult than making a portrait of a real person; in fact, perhaps it is easier, as you don't have to worry about creating an exact likeness. But you do need to be able to handle the watercolor medium with confidence, and this is where the step-by-step demonstrations and gallery of finished paintings will help you, providing practical hints as well as inspiration. All the paintings have been done by professional fairy painters working in watercolor, which, as they all agree, is the best medium for the subject, having something of the translucent, ethereal quality as the fairies themselves.

DIVERSE CHARACTERS

Any doubts about the subject matter, which might be seen by some as limited and perhaps sentimental, will be

JARDIN FAERIE ✱ JULIE BAROH This hand-colored linocut was painted in washes (originally it was done in black and white). The wings were particularly challenging for the artist as she had to depict them as transparent.

quickly dispelled by looking through the pages of this book, with its many and varied depictions of different types of fairy. These range from flower fairies and nymphs to sprites, sylphs, gnomes, and goblins. Not all fairies are good and kind—some are dark and sinister and some are downright evil. The sirens, who sit on rocks singing sweet songs, for example, do so only to lure unsuspecting sailors to their deaths, while goblins seldom if ever perform kind acts, and the otherwise lovable pixies sometimes steal human babies. So there is just as much scope for the artist in the fairy world as there is in the real one.

INSPIRATION FROM NATURE

Many fairies live in habitats familiar to us, such as gardens, flower-strewn meadows, trees, lakes, rivers, or rocky landscapes, so you can bring elements of landscape and flower painting into your fairy images. Nature also provides important sources for clothing, wings, or fairy homes— some fairies, for example, live in flowers or in toadstool houses—so whenever possible make sketches of leaves, flowers, mushrooms, and anything else associated with fairies. The setting for your fairy or group of fairies can be as important as the figures themselves, as it helps to build a complete picture of their natural habitat and their role in the fairy world.

DAVID RICHÉ

GIVEN TO FLY ✳
JAMES BROWNE
Flower fairies, who may appear alone or in playful groups, are tiny—the size of a flower bud, and sometimes even smaller.

PART ONE
GETTING STARTED

This first section clearly explains everything you need to know—from the basic materials you will need (including what paints, brushes, and paper to use) to developing skills that will enable you to capture the ethereal beauty of fairies. It covers techniques and character development, including creating textured effects, drawing magical creatures, and getting the right composition and perspective, giving you the confidence to experiment and create your own enchanting fairy paintings.

"Tree Nymph" by Virginia Lee

Materials

You don't need a vast quantity of materials to paint in watercolor. A basic range of colors, a small selection of brushes, watercolor paper, a palette, and a piece of sponge or tissue are all you require to get going, plus pencils and drawing paper to plan your work and map out the composition.

PAINTS

Watercolor paints are available in two main grades—artist's and student's quality. It is best to buy artist's quality, as they contain a higher proportion of pure pigment to fillers and binders, and will yield more vibrant colors. The paints are available in both tube and pan form. Tube paints are best for mixing large quantities of paint for a broad wash, or for adding touches of strong color. Pans, which are designed to fit into a paint box, and are made in half and whole sizes, are more convenient for small-scale paintings and detailed work, as well as for painting on location.

BRUSHES

Watercolor brushes are made from sable or other animal hair, or from synthetic fibers. Sable brushes are undoubtedly the best, but they are expensive, so it might be wise to start with synthetics until you have gained experience using them. Avoid cheaper animal-hair brushes, except when you need mops (usually made from squirrel hair) to paint large areas.

There are three main brush shapes: round, flat, and mop, with rounds being the

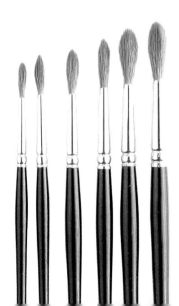

BASIC PALETTE

It is better to mix the colors you want from a palette of around 10 to 12 tubes or pans than to use a large range of colors straight from the tube, as mixing produces a more unified result. You may want to add a few other colors to this list, such as permanent rose, quinacridone magenta, brown madder, cobalt green, or turquoise, especially if you are basing your fairy forms on flowers. The following palette of colors should enable you to mix all the colors you will need:

French Ultramarine	*Aureolin Yellow*
Phthalo Blue or Winsor Blue	*Lemon Yellow*
Cerulean	*Cadmium Yellow Deep*
Phthalo Green or Winsor Green	*Yellow Ocher*
Burnt Sienna	*Cadmium Red Light*
	Alizarin Crimson

STRETCHING PAPER

When wet paint is applied to paper, it expands and buckles, creating dips in the surface where the paint collects and dries unevenly. To prevent this, you can stretch the paper before use by wetting it all over and taping it to a board; it then won't expand again when washes are applied. Heavier papers do not need stretching.

To stretch paper, you will need a wooden board such as plywood or MDF, 2 inches (5 cm) larger than the piece of paper; gummed brown tape 2 inches (5 cm) wide; and a sponge.

Cut four strips of gummed tape, 4 inches (10 cm) longer than the sides of the paper, then wet the paper on both sides with a sponge—or immerse it in a bath or large bowl. Shake off the excess water and lay the paper on the board. Wet the sponge and run the adhesive side of the tape across the top so that it is wet but not soaking, then place the strip along the edge of the paper and smooth it out, ensuring that it adheres to both paper and board. Repeat on the other three sides, then leave the paper to dry naturally.

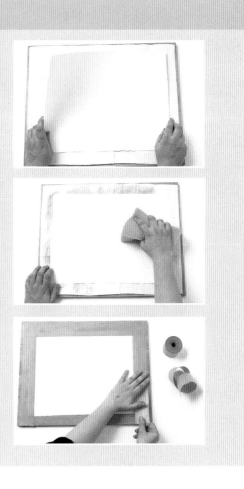

most versatile as they can be used both for broad washes and fine detail. Brush sizes are measured in numbers, beginning at 000 and going up to 20 or more. The best sizes for general use are 4 to 12, as these can hold a generous amount of paint, and also come to a good point to create lines of varying thickness. For closely detailed work and corrections, use sizes 000 (or 3/0) to 4.

Flat brushes, sometimes called "one-strokes," make distinctive chisel-shaped marks and hold plenty of color. They can be used for glazing (see page 20) and, in larger sizes, for laying washes. Mops are used for wetting paper before the application of paint, and for laying washes over large areas. A good general-purpose size is $^{3}/_{4}$ inch (18 mm).

WATERCOLOR PAPER

Most watercolor papers are made by machine, and are available in three surface textures: hot-pressed (or HP), cold-pressed (also known as CP or Not), and rough. Hot-pressed is the smoothest surface, and is best suited to very detailed or linear work. Not is slightly textured and is the best all-around, general-purpose paper for all watercolor and line-and-wash techniques. Rough works well for loose brushwork, wet-into-wet techniques, and textural effects, but it is tricky to work on, and is not suitable for detailed work, as the heavy texture breaks up fine lines and small details.

Papers come in a range of weights (in effect, thicknesses), measured in pounds per ream (lb) or grams per square meter (gsm).

The most common weights available are around 90 lb (200 gsm), 140 lb (300 gsm) and 200 lb (410 gsm), while the heaviest paper is about 300 lb (600 gsm). A good choice of paper for general work is 140 lb.

OTHER EQUIPMENT

Palettes made of ceramic or metal are ideal for mixing colors, and are easier to clean than plastic palettes. The latter, however, are convenient for working on location because they are relatively lightweight. Your palettes should have large wells for mixing large washes, and small wells for mixing smaller amounts of color. Sponges, cotton balls, paper towel, cotton swabs, tissues, and blotting paper are all useful for mopping up excess paint in washes, as well as for creating interesting forms and textures in a wash (see "Creating Textured Effects," page 22) and lifting off paint when you want to make alterations. They can also be used to apply paint. Salt crystals and white household candles enable you to create interesting textural effects in washes (see page 22).

Both masking fluid and a hairdryer for speeding up drying time are near-essentials. Masking fluid, a waterproof latex substance that dries to a rubbery consistency, allows you to reserve highlights without having to paint around them. Before laying on color, paint the fluid onto areas that are to remain white, and remove it after the subsequent applications of color have dried (see "Creating

Highlights," page 21). Another useful addition to your kit is a sharp-bladed scalpel or craft knife for scratching out small, linear highlights in the final stages of a painting.

DRAWING MATERIALS

▶ PENCILS AND ERASERS You will need pencils and erasers for sketching, trying out ideas, and making the preliminary drawing. The pencils can also be used for strengthening detail or shading in the final stages of a painting. HB, B, or 2B pencils are the best for drawing on watercolor paper, as they do not smudge too much and are easy to erase.

▼ SKETCHBOOKS Sketchbooks are essential for gathering material for your paintings. They are available in many sizes and types, some containing watercolor or pastel paper and others standard drawing paper, so you might consider keeping two or three for different types of sketches.

SKETCHBOOKS
Sketchbooks are ideal for collecting drawings of subjects for use as the basis for fairy figures and backgrounds; examples include studies of human figures, animals and insects, flowers, and landscape features.

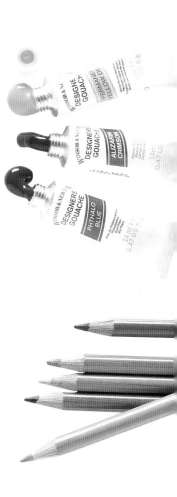

▲ **WATERCOLOR PENCILS** Water-soluble colored pencils can be used dry to add linear elements and details to watercolor paintings, or they can be worked over with a water-loaded brush to create a watercolor wash effect.

▶ **OPAQUE MEDIA** Gouache is an opaque medium similar to watercolor, and the two are sometimes used together. White gouache is especially useful for restoring highlights and for creating small, lightly tinted areas. Acrylic paints can also be used in combination with watercolors for highlighting or for touches of intense color. The drying time of acrylic can be slowed by using a medium called gel retarder. Another useful acrylic medium is acrylic gesso. This is designed for priming boards and paper.

OTHER MEDIA

▼ **PEN AND INK** A dip pen, in the form of a nib-holder with a range of drawing nibs, is ideal for drawing and line-and wash techniques (see "Line and Wash," page 19). You need waterproof (India or acrylic) ink for combining line work with washes, as it does not run when watercolor is applied on top. Fiber-tipped drawing pens can also be used, but make sure they are waterproof and light resistant (some inks fade badly over time).

▼ **PASTELS** Soft pastels (below), pastel pencils (right), and oil pastels (bottom) are ideal for sketches on location and planning color compositions. All three can also be combined with watercolor (see "Wax Resist," page 22 and "Using Mixed Media," page 23).

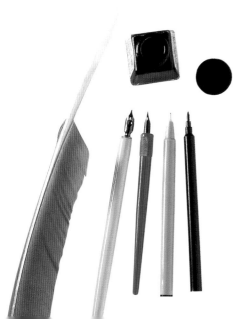

Watercolor Techniques

The translucency of watercolor makes it the perfect medium for capturing the ethereal, fleeting nature of the fairy world. Watercolor can be an unpredictable medium, especially when employing wet-into-wet methods, as the paint tends to spread where you don't want it to and run into other colors, but with practice you will learn to control it.

You may also discover new techniques through your mistakes, as accidental effects such as blotches and backruns can often be used to your advantage to suggest texture or to create interest in a background.

PUTTING PAINT TO PAPER

Watercolor can be used in a range of dilutions, from almost dry to very dilute, and can be applied to wet, damp, or dry paper. Each wash-and-paper combination produces a different effect, as shown in this series of illustrations (left column).

◄ DILUTED COLOR When applied to wet paper (top left) the paint spreads out, effectively diluting the color, and dries with a soft edge. The extent of the spreading depends both on the paper surface and on the degree of wetness; the rougher the paper, the less it spreads, and the wetter the paper, the faster and farther it will spread. But when applied to dry paper (left, second from top) the paint stays where it is placed, giving more depth of color than when applied to wet paper, and dries with a hard edge.

◄ SEMI-DRY, UNDILUTED PAINT When applied to wet paper (left, third from top) the paint spreads only slightly. This method is useful for adding spots of intense color with softened edges. But when applied to dry paper (bottom left) the paint does not spread at all. This method is good for textural effects and fine detail.

LAYING A WASH

In the early stages of a painting you may want to lay a wash over a large area, or even over the whole paper, to form the basis for a background. It is important to complete the wash quickly without pause, so mix up twice as much paint as you think you will need, and work with your board propped up at a slight angle.

▶ FLAT WASH To create a flat, uniformly toned wash, load your brush well and, starting at the top, draw it across the full width of the paper. Reload the brush and paint a second band of color just touching the first one, picking up any excess paint at the bottom of the first band. Work downward in the same way until the paper is covered. For a softer effect, dampen the paper before applying the wash.

◀ GRADATED WASH For skies, which are darker at the top than the bottom, you can vary the tone of the wash so that it goes from dark to light, or from fully saturated color to pale. Begin with the strongest color and gradually add more water for each subsequent band of color.

▶ VARIEGATED WASH For a wash that changes from one color to another, perhaps from blue to green and then yellow, mix up all the colors in advance and dip your brush into each one in turn. Dampening the paper helps the colors to merge into one another.

A more random variegated wash can be achieved by working wet into wet (see page 18), laying a base wash on damp paper and working more colors into it until you have the effect you want. You can tip the board in different directions to influence the way the colors spread.

PAINTING METHODS

The classic method of building up a watercolor is to lay a series of thin, transparent washes, one over the other, working from light to dark, and reserving the white of the paper for highlights. It is possible to create very detailed paintings without building up in layers, by painting each area separately with full-strength color, but this involves careful advance planning so that you know exactly what color to put where.

An alternative to the layering method is to work wet into wet, mixing the colors on the paper surface rather than in a palette. This is best suited to loose, expressive work (see right), and is thus not the best method for painting details of fairy wings and garments or flowers and plant forms. However, it can make a good contrast to tighter wet-on-dry work if restricted to certain areas of your composition, such as skies, rocks, and water.

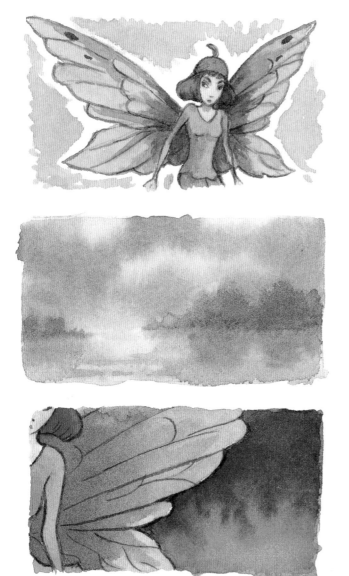

◄ **WET ON DRY** Layering new (wet) washes over earlier ones that have been allowed to dry fully allows you to build up a good depth of color, although you will have to wait—sometimes for long periods—for the paint to dry before the next color can be added. It is important to wait until each layer is completely dry or the colors will bleed into each other. However, remember that you can paint some parts of a picture wet on dry, and other parts wet into wet (see below).

◄ **WET INTO WET** This method, as the name implies, involves dropping a new color into a still-wet wash so that the colors spread into one another. With practice, you can learn to control the results by judging the wetness of the paper—if it is too wet, the colors will merge completely, but if you wait until the sheen is off the paper, the new color will spread out slightly and dry with soft edges while still retaining its identity.

◄ **BACKRUNS** If the second or subsequent colors have a higher water content than the first ones, the water will spread outward, leaving a lighter blotch in the center, which will dry with jagged, irregular edges. These blotches are called backruns, and are often deliberately induced to add interest to backgrounds or suggest unspecific shapes in areas of foliage, rocks, or stones.

◀ DRYBRUSH Stippled, dabbed, or hatched marks can be made over a dry wash to add detail or to create an impression of texture, as when painting feathers, fur, hair, and grasses. Pick up a small amount of paint with the tip of a damp brush, and hold it as you would a pencil to make small, thin lines. To produce thicker marks, apply more pressure as you draw the brush across the paper. The speed of the brushstroke influences the amount of paint deposited on the paper. The faster your brushstroke, the less paint will adhere to the surface, leaving flecks of the first wash color showing through to create a lively broken-color effect.

LINE AND WASH Combining line work with color washes allows you to render fine detail without fiddling with a tiny brush. This can be very useful when you are painting small, delicate subjects, such as fairies or plants. Since this method requires fewer layers of color than pure watercolors, the results can look fresh and spontaneous, and hence this is a very popular method of illustrative work.

▶ The traditional technique is to make a line drawing in ink, allow it to dry, and then apply flat washes with a brush, either in layers or in separate areas. However, this can give the rather lifeless impression of a "filled-in" drawing, so to keep the image lively and to integrate the drawing and the color, try to avoid placing the washes exactly within the drawn areas (top right).

▶ Another approach (bottom right) is to lay the washes first to establish the main colors and areas of light and shade, and then draw over the top when these are dry. If you are doing this then note that you will need a light pencil sketch as a guideline. And, of course, the two methods can be combined, with the image gradually built up with line, then color, and then more line.

▶ USING COLOR To make a color wheel place the three primary colors at intervals of one third around the wheel, and then add the secondary colors halfway between them. The tertiary colors are made up of a mix of the two. Colors that are next to each other are known as harmonious colors; while colors opposite one another are referred to as complementary. You can use these properties and relationships to juxtapose and oppose particular colors in your paintings, for example, by dabbing a little red in a green plant.

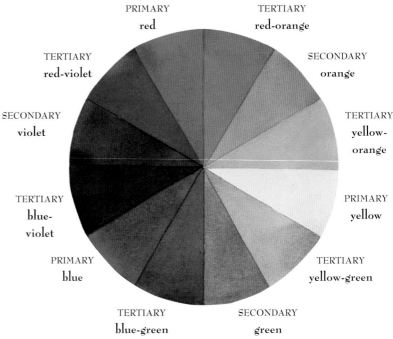

PRIMARY
red

TERTIARY
red-orange

TERTIARY
red-violet

SECONDARY
orange

SECONDARY
violet

TERTIARY
yellow-orange

TERTIARY
blue-violet

PRIMARY
yellow

PRIMARY
blue

TERTIARY
yellow-green

TERTIARY
blue-green

SECONDARY
green

TRANSPARENT PIGMENTS

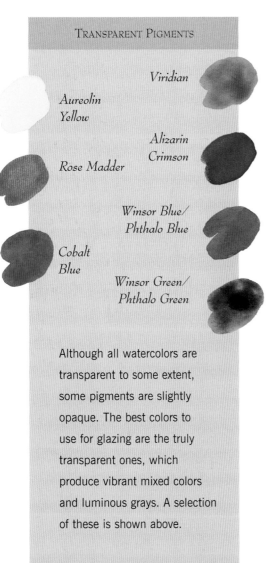

Viridian

Aureolin Yellow

Alizarin Crimson

Rose Madder

Winsor Blue/ Phthalo Blue

Cobalt Blue

Winsor Green/ Phthalo Green

Although all watercolors are transparent to some extent, some pigments are slightly opaque. The best colors to use for glazing are the truly transparent ones, which produce vibrant mixed colors and luminous grays. A selection of these is shown above.

▼ GLAZING This is a variation on the wet-on-dry technique, which allows you to mix, alter, or amend colors on the paper surface. Instead of mixing secondary colors on the palette, you can glaze blue over yellow to produce green, and red over yellow to create orange. Areas in shadow can be pulled together by glazing blue over an entire section of the painting, and grays can be produced by layering varying mixtures of red, yellow, and blue, or by using complementary colors, such as red and green. Glazing is an invaluable technique that enables you to create luminous, glowing hues. It also gives you a high degree of control over the painting process.

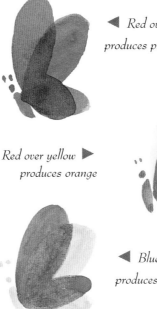

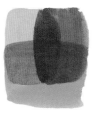

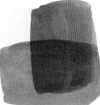

◀ *Red over blue produces purple*

Red over yellow ▶ *produces orange*

▲ *Red, yellow, and blue overlaid produces gray*

◀ *Blue over yellow produces green*

▲ *Orange, green, and purple overlaid produces gray*

EDGES

Working on wet or damp paper results in soft, blurred edges, while an area of color applied to dry paper creates a hard edge. It is important to vary the edges in your paintings, because they have an effect on the perceived spatial relationships; soft edges give an out-of-focus effect, pushing the area back in space, while hard ones separate areas of color, pushing one forward and another back in space.

Hard edges on a first wash or brushstroke will show through subsequent colors, so if you want a soft effect, perhaps in a background, soften the edge right away before the paint dries by running a clean, just-damp brush along the edge and repeating this until you have achieved the required degree of softness.

▶ *If the paint has dried, re-dampen the edge and work over it in the same way, either letting the paint spread a little or absorbing some of it with a paper towel or a tissue.*

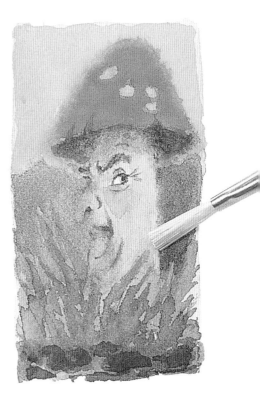

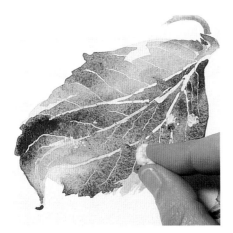

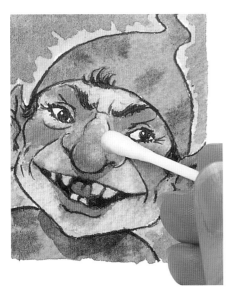

CREATING HIGHLIGHTS

Unless you plan the highlights in advance, it is all too easy to end up with no areas of white paper, so draw out your composition before painting. When you have established where you want the highlights, either reserve them by painting around them, or apply masking fluid (see below) to protect the highlight areas while you paint.

◀ MASKING FLUID This is especially useful for creating small, intricate patterns of highlights, such as sunlight on foliage or vein patterns on wings or leaves. Use an old brush or pen to draw with the fluid, and when the washes have dried, remove it by rubbing with a finger or a kneadable eraser. If the white of the paper appears too strong in relation to the surrounding areas, you can modify it by applying a pale, tinted wash.

◀ LOST HIGHLIGHTS Highlights that have become lost during the painting process can often be reclaimed. One method, which should only be used on heavier papers, is to scratch them out by dragging a knife blade over the paper surface. Paint can also be removed by lifting out with a damp brush, working gently until you have removed sufficient paint, and then blotting the surface with a tissue or blotting paper. Highlights can also be reinstated by painting over the area with gouache or acrylic paint, either white or lightly tinted with watercolor.

CREATING TEXTURED EFFECTS

There are several ways in which to create atmospheric and textured effects, which are often used to introduce interest in backgrounds of fairy paintings.

▶ WAX RESIST Wax repels water, so when wax is applied to paper and then wet paint is added, the paint will run off the wax to settle only in the non-waxed areas. Because the wax clings to the top grain of the paper, this creates a speckled texture that can be used to capture the effect of weathered or rough surfaces, such as rock and wood. If you want white highlights and specks, you can use a household candle to scribble over the paper, but you can also achieve colored effects by using wax crayons or oil pastels.

▶ SALT Dropping salt crystals into a wet wash produces a dappled effect that might suggest sunlight on foliage or starbursts in a night sky, or simply create a more abstract textured background. Apply a wash and then heap salt crystals into it. The wetter the wash when you add the salt, the more color will be absorbed by it. Leave until the wash is dry and then shake off the salt.

▼ SPONGING AND SPATTERING Paint can be applied with a sponge onto a wet or dry wash to build up textured and modeled effects. Sponges can be used quite precisely, while spattering paint creates a more random effect that might suggest falling snow, or give an illusion of detail. To spatter, pick up paint with a stiff brush and then either flick it on to the paper or tap the handle with another brush to release droplets of color.

▼ STAINING PAPER A simple but effective way to produce a pale, warm background is to stain your watercolor paper with diluted coffee.

USING MIXED MEDIA

Many different drawing and painting media can be combined with watercolor, including colored pencils, pastels, oil pastels, colored inks, acrylics, and gouache. The last two are useful for putting in highlights and very light tints of color in the final stages of a painting, but can also be thinned down and used hand-in-hand with watercolor as part of the painting process. This can give strength and solidity to the painting and create stronger tonal contrasts than is possible with watercolor alone. However, gouache does not have the luminosity of watercolor, and its overuse can create a dull, lifeless effect.

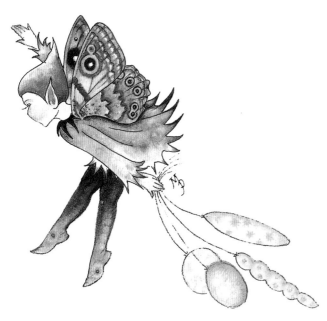

MAKING CHANGES AND CORRECTIONS

There are several ways in which you can change, correct, or modify parts of a painting. If you need to remove color while the paint is still wet, you can simply blot it with blotting paper or a sponge to remove most of the moisture, and then repaint the area when dry. If only a tiny area has been affected, then you may prefer to use a wet brush. Depending on the pigment and the type of paper used, dry paint can be more difficult to lift out, as some colors may leave a stain, but you can usually remove most of the color with a damp brush, sponge, or cotton swab and then sharpen it up if necessary with opaque white.

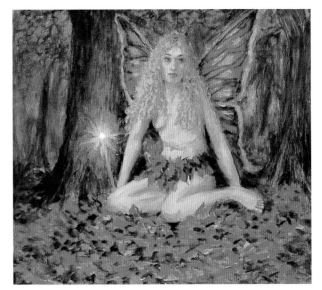

▲ ACRYLICS Acrylics can be used to paint the first layer of a watercolor painting, to achieve an intensely colored wash, which is then painted over in watercolor. They can also be applied over dry watercolor washes to add intense spots of color and to sharpen up detail.

◀ DRY MEDIA Colored pencils and pastel pencils can be used over dry watercolor washes to sharpen up detail and intensify colors, while soft pastels are sometimes used to provide touches of surface texture. Oil pastels are not a natural partner for watercolor, but they are useful for the wax-resist technique described on page 22.

▲ Small unwanted blobs and specks of paint can be scratched out as described on page 21, but do not try to repaint these areas as the paper surface will be slightly roughened and will not take the paint evenly.

From Sketch to Finished Painting

Always carry a sketchbook with you, and take every opportunity to sketch suitable subjects, such as figures, plant forms, and everyday objects, all of which can provide the structural basis or inspiration for fairy forms and their dwelling places.

DRAWING

Begin with simple drawings, and try to get the essence of the subject rather than dwelling on detail. Pencil is the best all-around medium for monochrome sketching, but charcoal or conté crayon are both good for tonal studies. Watercolors are ideal for color sketches, but don't try to make them too perfect, work quickly, and don't worry about blotches and backruns.

▶ FIGURES Try to establish the body's overall shape and proportions before moving on to the individual parts. Hold up your pencil to check the proportions as you draw, selecting an element such as the head as your measuring unit. Look for the directional lines and angles within the figure in relation to imaginary horizontal and vertical lines, as these are vital to capturing a pose convincingly. Also note where the weight is, and how the body is balanced over its center of gravity. If a person is standing with most of the weight on one leg, you can draw a vertical line down from the ear to establish the position of the weight-bearing foot.

You can use photographs as the basis for figures, but drawing from life will give you a better understanding of the human form.

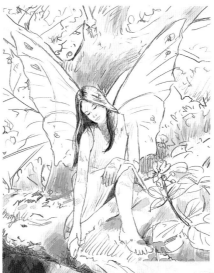

DRAWING FIGURES
When drawing figures it is a good idea to make a series of small thumbnail sketches to work out the best placement of your figure, as well as the proportions of the different body parts.

THE HEAD
Always think carefully about how you position the head, as attention will naturally be drawn to the face.

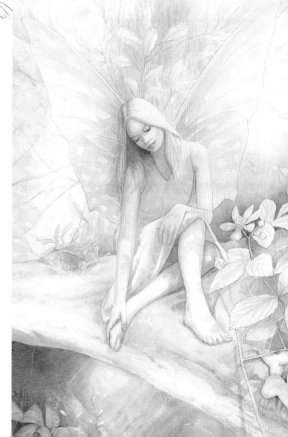

FLOWER FAIRIES
These delightful fairies were inspired by the flowers of the Bleeding Heart (Dicentra spectabilis) *plant and Parisian trapeze artists.*

MOVING FIGURES

When you are sketching figures in motion, aim to capture the posture and balance precisely, but don't bother with features or details. Study the appearance of figures as they move. When a person is walking or running, their body weight is unevenly distributed, the body moving in the direction where the volume is greater. The outlines of figures in movement are more blurred, and less detail is observable.

▲ FLOWERS AND PLANTS The huge variety of forms, patterns, colors, and textures seen in nature can provide endless inspiration for the settings of fairy paintings, so the more studies you make of plants and other natural forms the better. Discover the rhythms and patterns within the arrangement of petals, foliage, and shells. Although you can photograph these details, making drawings from life will give you ideas for using natural forms, patterns, and textures.

PERSPECTIVE

A basic understanding of perspective will help you make figures and their surroundings convincing, whether you are using a real setting or painting an imaginary world. Perspective is no more than a set of simple rules that allows the artist to create the illusion of three dimensions on a flat piece of paper, and the basic rule is that things appear to become smaller the farther away they are. And as objects shrink in size, so do the spaces between them, so that parallel lines receding into the distance appear to converge on an imaginary line called the horizon. This line is, in fact, your own eye level, and it is worth bearing in mind that the heads of any figures of roughly the same height will be on or near the horizon, while their feet will be farther up in the picture depending on their position in space.

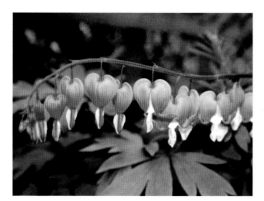

USING REFERENCES
Photographs provide a good year-round reference, but it is better—if possible—to use real flowers and plants so you can see the texture and patterns.

▼ VIEWPOINT AND SCALE You have the freedom to place the eye level where you want in your painting. In a normal view, it will be slightly above or below the middle of the paper, but if you place it high in the picture, you can make figures or objects appear smaller than normal. Conversely, a low viewpoint makes them appear larger.

▼ FORESHORTENING Perspective affects figures in another way, creating an effect known as foreshortening. Not only do the closer parts of the figure appear larger, but they also decrease in height. For example, if a figure seated in a chair is facing toward you, the thighs will be foreshortened to perhaps half of their actual length. In such cases, hold up a pencil at arm's length to check the measurements of the thighs in relation to other parts of the body.

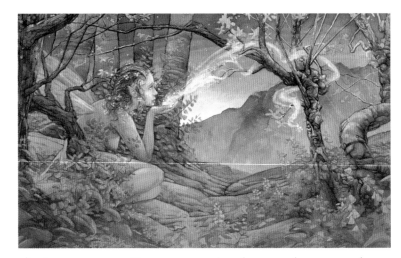

▲ ATMOSPHERIC PERSPECTIVE Another way of creating a three-dimensional effect is to use what is known as aerial or atmospheric perspective. Moisture and dust in the atmosphere create a kind of veil, so that little detail is visible on distant objects or landscape features, and colors appear paler and cooler, with little tonal contrast. To suggest distance and recession, use stronger, warmer colors in the foreground and weaker, less saturated ones in the background.

COMPOSITION

When planning a composition, you can either create the setting first and place your figures in it, or draw the figure first and build the setting around it. Either way, your fairy figure or group will be the center of interest, so decide where you want to place it. Avoid putting the main figures in the center of the painting, and instead position them above or below the middle or to one side. If there are several figures, don't string them out in a straight line. A better approach is to create a larger figure or group balanced by a smaller one or some other element. Don't be afraid to overlap figures, as this creates a relationship between them.

SHAPES Try to see the elements initially as shapes rather than as specific objects and figures, and use these shapes to create an interesting, well-balanced pattern. Also visualize the spaces between the main shapes and between an object and the edges of the picture. These spaces are known as negative spaces, and play an important part in composition. Try to create an interplay between positive and negative spaces, but don't make an equal division between the two, and vary the size of the negative spaces. Small pockets of enclosed negative space of different shapes and sizes, for example, between a torso and arm or between plant stems, can add visual excitement, as the eye will rove quickly from one to another.

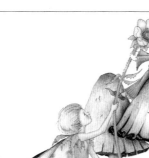

TRANSFERRING YOUR SKETCH

When you are happy with your composition, transfer it to your painting surface, either by lightly drawing freehand or by tracing. If you need to scale up a small sketch or photograph and do not have access to a photocopier that enlarges images, draw a grid on the smaller image and a larger one on the painting surface, and copy the image square by square.

▼ BALANCE AND MOVEMENT

To make a good composition, each element needs to be balanced by others, either through shape, color, or tone. For example, a jagged shape on a headdress could be echoed by a spiky tree form, or an area of bright color on clothing could be repeated on flowers to link the different parts of the painting. But these echoes and balances must be kept subtle—never repeat exactly the same shape or color area.

It is also essential to create a sense of movement so that the viewer's eye travels into and around the picture. This can be done through directional lines leading from one area to another as well as through the placement of the figure or figures. A centrally placed figure will look static, but if positioned in the upper half of the painting it will appear to be floating through the air, and the eye will naturally follow it. If a figure is running or jumping, place it off-center to create an empty space into which it can move.

▲ DEVELOPING THE SUBJECT Start by making sketches to try out

different arrangements of the main figures and supporting features. Make a series of line, tone, and color studies until you are satisfied that you have the basis for a strong composition.

PLACING A FIGURE IN A BACKGROUND SKETCH

To draw a figure or group of figures into an existing background, make a tracing of the figures and place this over the sketch, moving it around until you are satisfied with the composition. Alternatively, cut shapes out of drawing paper or colored paper.

If you are combining elements from different photographs or sketches, you will need to unify the composition through tonal pattern, color, and angle of view. Overlap forms so that foreground elements extend into the middle-ground, and middle-ground objects extend into the foreground and distance to give an impression of depth and unity.

MAGICAL MOVEMENT

To show movement, use fluid rather than straight lines, as straight lines will make your image appear robotic. Watch flowers, leaves, clothing, and dress materials blowing in the breeze—all of this helps to create movement.

Character Development

The first step is to visualize the type of fairy you intend to depict, so think about the main character traits—is it innocent, friendly, mischievous, troublesome, or perhaps even wicked? Consider also where the fairy lives, how and what it eats, and how it moves about. Its role in the fairy world is also important, as this will dictate its appearance.

To develop your ideas about character, make a series of drawings, letting your imagination take over as you work, and experimenting with different approaches. This is where regular sketching from life becomes really helpful, as your imagination is fed by the very process of looking and drawing, and you will gradually amass sketchbooks full of visual reference material to build on.

GOOD AND EVIL

Character and atmosphere can be conveyed in a painting in many ways, including the balance of light and shade, the choice of colors and shapes, and the exaggeration of forms. Color has a strong influence on mood. In general, primary colors suggest high spirits and energy, while pastel shades give the impression of youth and innocence. Darker tones and more heavily mixed colors can convey an atmosphere of evil and foreboding.

Shapes also play a part in suggesting character. For example, rounded or curving shapes can give an impression of youth and happiness, while angular, sharp, jagged, or pointed shapes can signify danger and evil. Try to find ways to repeat and echo a particular shape or visual characteristic, such as spikiness, for example, throughout the figure—in the face, hair, headdress, wings, hands, feet, and so on.

THE HUMAN FORM

You can play with endless variations and distortions of the basic proportions of the human figure. In a normal human, the head is usually used as a yardstick for the proportion of the body—the standing body is

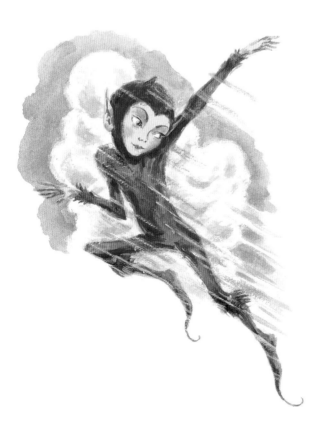

GOOD VERSUS EVIL
Good and evil can easily be conveyed in the colors used in your painting. Darker tones—blacks and dark reds—imply evil, while light pastel shades indicate purity.

BALANCING
FEATURES
*By using the standard
proportions of the face,
but with other fairy
attributes such as
wings, you can create
an otherworldly
creature who seems
enchantingly human
(left and below).*

FACIAL CHARACTERISTICS
*A strong or heavy feature needs to be balanced by
other similar features, such as deep-set eyes and a
wide, bulbous nose.*

about seven-and-a-half heads high. There
are many ways to vary and exaggerate these
basic proportions: by making the head larger,
for example; the torso longer, or more squat
and rounded; and the arms and legs
elongated and spindly. But bear in mind that
however much you exaggerate certain
features, the figure must still look credible,
for example, the legs and feet must appear as
though they can support the body.

HEADS AND FACES The shapes of faces
vary widely, but the basic proportions are
always roughly similar. The eyes are halfway
between the top of the head and the bottom
of the chin, while the tops of the ears line up
with the tops of the eyes, and the bottom of
the nose with the bottom of the ears. You
can vary the overall shape and proportions
by introducing an exaggerated roundness, or
by making the face appear thin or elongated.
Or you can exaggerate just the lower or
upper half of the face.

CHILDREN'S HEADS
*A child's head is larger in relation to its body size than
an adult's, making its body about five to six heads
high. In very young children the head is larger still in
relation to the body.*

Think about your character's role in the
fairy world—what it has to do, and where it
lives. A fairy living underground would have
physical characteristics different from one
who dwells in water, air, or a realm beyond
the rainbow. Try to use the features
themselves to convey character rather than
relying on facial expressions. Close-set eyes
and a hard, piercing stare, for example, can
give a better impression of a malevolent
character than a scowling expression. Youth
and innocence are best expressed with the
use of simplified features and light shading,
whereas old age or menace can be suggested
with more solid shading to create heavier,
deeper-set, or more exaggerated features.

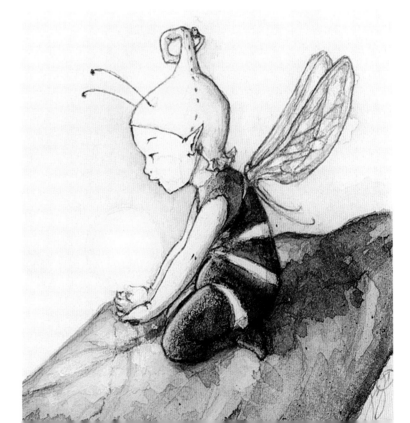

EYES Eyes are vital to character, so pay special attention not only to the shape but also to the spacing and the way they are set into the eye sockets. Eye size can help to suggest a character's way of life; for example, a fairy living underground might have very large eyes in order to see in the gloom. Try drawing different eye shapes, making them round, slanted, or drooping, and experiment with different methods and degrees of shading. You could also try drawing a sequence of eyes from open to closed to see how the mood alters as the lids lower.

NOSE AND MOUTH The nose and mouth should be developed in relation to other features as well as the overall face shape. Think of the nose as a simple triangle shape, and build up variations on that, whether small and pointed, upturned, bulbous and broad, or long and hooked. Mouths, being the most mobile feature of the face, convey much of its expression and give an idea of the character's mood or intentions. An upturned mouth suggests a cheerful and benevolent mood, while a downturned one conveys ill temper or suspicion and dislike.

▼ HANDS AND FEET Hands and feet can be distorted, perhaps by developing them into talons, elongating the fingers and nails, and enlarging the joints. But you must first understand the basic structure and articulation of the joints, so practice drawing your own hands and feet from different angles and in various positions.

To achieve a consistent character image, make sure that the feet match the hands, but also consider the weight they have to carry; if the body is large and the legs thin and elongated, the feet must be elongated as well so that the figure can be balanced over them.

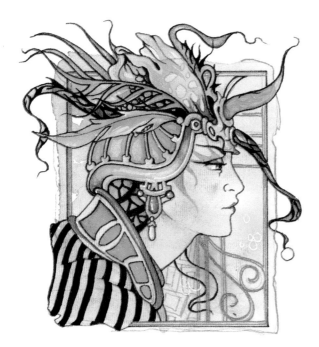

▲ HAIR AND HEADDRESSES Hair plays an important role in building up character and suggesting the fairy's role and habitat. It can be loose and wavy, long and flowing, spiky, or snake like. It can have flowers, twigs, or fruit woven into it, or the hair itself can be shaped into a cap. Alternatively, husks, petals, leaves, shells, or toadstools, all associated with fairies, can be used as caps, or more elaborate headdresses can be devised—there are endless possibilities.

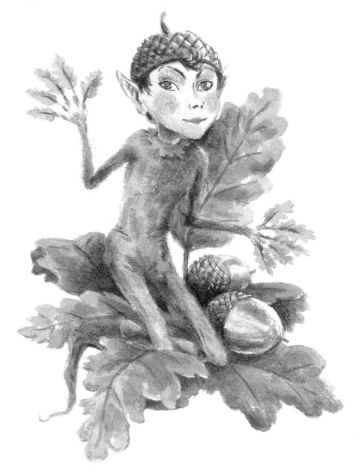

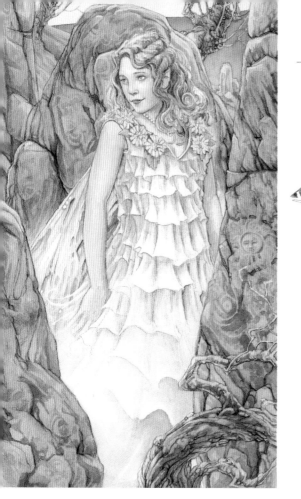

FABRIC
You can use fabric to invoke a sense of movement in a figure by the way it follows the contours of the body, and swirls or swings with the direction of the movement.

COSTUMES

Drawings of period costumes are a useful source of inspiration, and can be used either as they are or as a basis for a design of your own. Think about the kinds of fabric you will be using, as these vary widely and their special characteristics will influence the way you depict them.

Folds in fabric are suggested by shading the inner part of each fold. Lightweight cottons and silks have a great many small folds that follow the contours of the body, so keep the shading light. Thick fabrics such as velvets and wools have fewer, deeper folds, and will require heavier shading to make the fabric look static.

When "dressing" a flower fairy, look for the basic shapes of petals and leaves and use

VEINING
Veining, for example to create wings, can either be drawn in precisely with pencil or ink, or it can be made by masking or lifting out.

these either to develop a whole costume or to add details. You might wish to camouflage the fairy on a particular flower or in a specific setting by echoing colors and shapes in the flowers and petals, while the patterns of veins on petals and leaves could be repeated or lightly echoed on the wings.

WINGS

Wings can be based on any number of natural forms, including those of butterflies, moths, dragonflies, bats, or leaves and petals. Any of these can be used in their natural shapes or developed and adapted to create elaborate or extended wings, worn and ragged wings, or angular and spiky ones. Fairies' wings are often a dominant feature of paintings, playing a vital role in the composition, so consider how to place them in relation to the body—they may look more interesting if they are not entirely symmetrical.

ETHEREAL WINGS
Patterning on the wings can be painted in to good effect by using loose, wet-into-wet washes.

Part Two
Directory of Fairies

Turn your brush into a wand and create a magical world inhabited by nymphs, goblins, pixies, and water fairies. This section of the book contains a beautifully illustrated gallery of inspirational work, as well as the essentials, which will give you specific ideas and images from which you can choose numerous kinds of fairies to paint. Divided into the realms of the fairy world—from nature's fairies and dark fairies to fairy helpers—there are also seven enchanting yet easy-to-follow step-by-step projects that you can recreate.

"Egan" by James Browne

NATURE'S FAIRIES

Fairies prefer the quiet of the wood or meadow to the bustle of the city. All natural things are in their care, from the tiniest flower to the fiercest forest animal.

ROSE FAIRY ✶ MYREA
PETTIT (left)
The artist used her young
daughter, Eleanor Rose, as a model
for this charming image. It was drawn with
very sharp watercolor pencils, with the colors buil
up gradually from light to dark. An eraser was used
to blend the colors, as well as to lift out small areas
such as the smaller leaf veins, before adding white on to
to create highlights. For additional definition, the wing an
the edges of the rose petals were delineated with black ink.

DAWN FAIRY ✶ JAMES BROWNE (below)
The twisted, gnarled figures that form the tree trunks
were initially drawn in ink, but the artist chose brown
rather than black to give a softer line, which would
merge with the subsequent washes. The fairy and the
rest of the image were then sketched in pencil before
being gradually built up in a series of watercolor washes.
The opalescent skin tones, the stardust, and some of
the foreground flowers were painted last in a semi-
opaque wash of white and yellow ocher gouache.

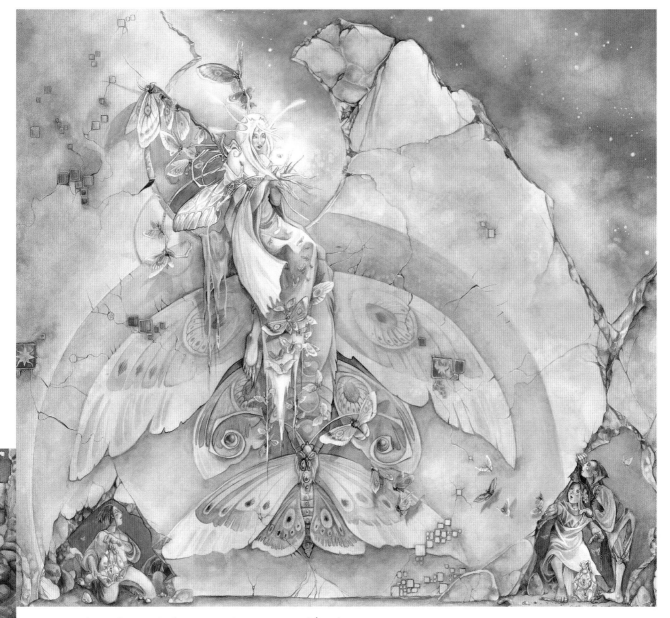

MOTH FAIRY QUEEN ✴ STEPHANIE PUI-MUN LAW (above)
The artist wanted to give an organic feel to the painting, and
has exploited curving and curling shapes in the central moth
motif, which forms a subtle background to the fairy queen.
Throughout the painting, she has used delicate, transparent
washes, which allow much of the white paper to show through.
This can be seen clearly in the sky area, where a shimmering
cloud effect has been created by gently dabbing a paper towel
into a wet wash of cobalt blue.

RAIN FAIRY ✴ MARIA J. WILLIAM (right)
Paying attention to tiny details like these raindrops on the
flower allows you to create an authentic small-scale fairy
world. The artist has cleverly suggested a head on the bud by
placing two drops for eyes. The intricate veins running through
the petals, delicate wings, and textured hair were drawn over
a base layer of pale watercolor washes with colored pencil.

SPRING FAIRY ✳ WENCHE SKJÖNDAL
(below) This coy, scantily clad fairy,
treated naturalistically except for the
long, pointed ears, sits on a leaf in a
meadow full of flowers, gazing wistfully
at the observer. To emphasize the spring
like feel and the delicacy and fragility
of the pale figure, the tones have been
kept very light and the colors are muted
and restrained, consisting of soft
browns, yellows, and greens. A careful
preliminary drawing was made in
pencil, and the painting was built up
in layers, with loose, wet washes.

PASSIFLORA ✳ LINDA RAVENSCROFT (above)
A fast-growing passionflower in the artist's garden brought to mind the
story of Jack and the Beanstalk and other such fairy tales, and the lovely
plant, with its huge white flowers and twining stems, also provided the
perfect setting for the deva, or flower fairy. The painting has a distinct
Art Nouveau flavor, and the composition is finely balanced, with the
fairy and the three flowers forming a cross shape, and the upper tendrils
on the right balanced by the butterfly on the left. The image was drawn
in waterproof sepia ink with the background painted wet into wet and the
fairy and plant details built up in wet-on-dry layers.

THE DEW FAIRY ✳ JAMES BROWNE (below)
Dewdrops have always been associated with fairies—they are
believed to feed on them, or wear them on their gowns in place
of diamonds, and here a tiny, graceful fairy pours dew from
a leaf. The use of light tones and a limited color scheme of
fresh greens and yellows inspires a feeling of innocence as well
as suggesting springtime and the brightness of early morning.
The sparkling dewdrops were carefully shaded and highlighted
to give them a three-dimensional appearance, and a little sepia
ink line has been added in places to provide touches of
definition in the foliage and the facial features.

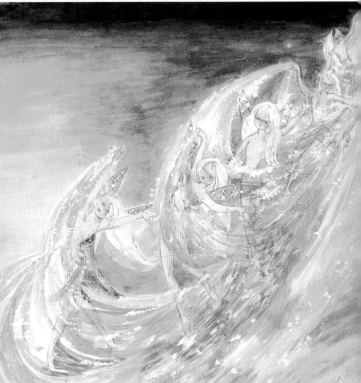

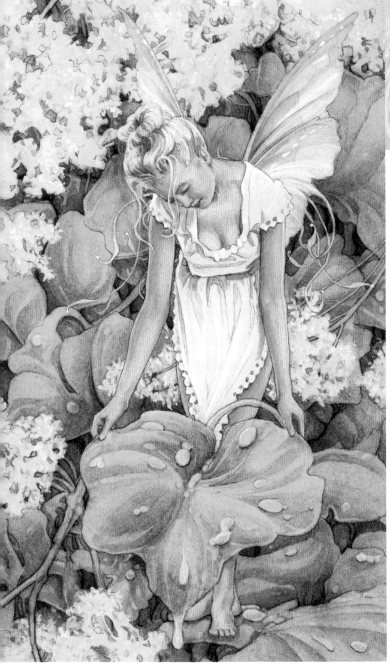

FAIRIES DANCE IN WATER ✳ ANN MARI SJÖGREN
(above) Five vivacious fairies dance in their watery
element, their movements whipping up diaphanous
wisps of frothy, sparkling waves. The waves are
described by vigorous brushwork, and the whole
painting has been kept light and loose, giving
the impression that the fairies are floating and
insubstantial as well as being vibrant and animated.

IN THE ROSE GARDEN ✳ WENCHE SKJÖNDAL (left)
The models for these two little fairies were young friends of the artist and were sketched from life, as were the roses, which the artist discovered in a public garden. The sprites, sheltered by the lush, heavy blossoms, gaze out at the viewer and seem to lure us into their magical world. The whole of the picture was drawn in great detail, and the paint was used wet on dry, with the white of the paper reserved or only lightly covered for the paler areas.

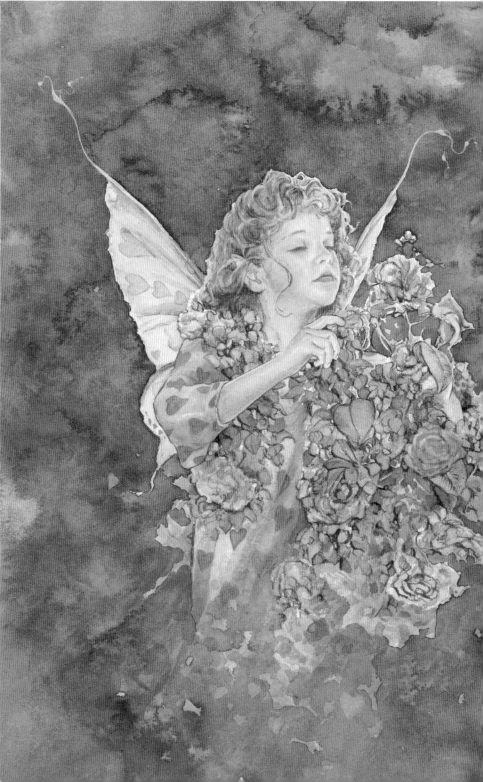

AMOUR ✳ JAMES BROWNE
(right) This sentimental fairy, who literally wears hearts on her sleeve, was originally created for a greeting card. We might imagine that her young face is flushed with the dawning of first love, but has she just received the huge bunch of pink roses or is she about to give it to the object of her adoration? The muted background was achieved by painting wet into wet with washes of brown, pink, and green, and although the treatment of the fairy is more detailed, the artist has worked lightly to retain the delicate airiness of the wings, head, and arm.

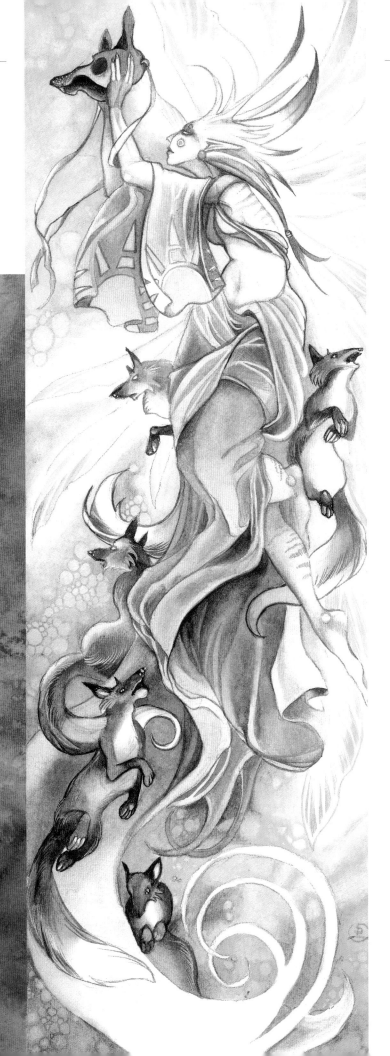

FOX SPIRITS ✳ STEPHANIE PUI-MUN LAW (left)
A dynamic sense of upward movement has been created
by the elongated vertical format and the spiraling
composition. The leaping foxes and flowing curved
lines all lead the eye up to the topmost figure, who
holds an intriguing fox mask. The textured background
was produced by laying a series of very light but
deliberately uneven washes, lifting out small areas, and
outlining these paler spots in darker paint. All the
lighter areas were achieved by retaining the white
paper—no white paint was used.

BRIAR ROSE ✳ KIM TURNER (above)
The fairy Briar Rose gazes steadily out of this
painting. Like all good "portraits," this painting gives a
sense of engagement and a feeling that we know the
person portrayed. Although the overall effect is soft
and pretty, we can see that Briar Rose is a strong and
determined character. The painting was built up using a
series of overlaid wet-on-dry washes, with highlights
reserved as white paper, and details added with
watercolor pencils.

Flower Fairies: The Essentials

There is an old legend that fairies are born in flowers, and certainly the two are closely associated. Many people still believe that fairies cause plants to grow, flitting from blossom to blossom, ensuring that the buds open in spring and then wither again as summer gives way to autumn. Images of such creatures have become very well known since Victorian and Edwardian times, when several popular illustrators assigned each flower to a particular fairy, and depicted fairies clad in the petals and leaves of their plant.

FLOWERY GARB

✳ Try incorporating elements of plant material into the clothing, forming skirts from tiered petals or leaves, for example, or decorating bodices with seeds or a collar of fluffy dandelion seeds or frothy elderblossom. For hats and caps use acorn cups, pine cones, upside-down daisies, and folded leaves.

TREES AND BLOSSOMS

✳ Flower fairies are depicted with their own special plants or trees, and may be shown swinging from the boughs, playing with the seeds, balancing on twigs, sniffing the blossoms, or using the blooms of the trees or plants as parasols. By dressing a fairy in the colors of the plant, you can reinforce the connection between the two.

TINY FAIRIES

✳ Flower fairies, who may appear alone or in playful groups, are tiny—the size of a flower head, and sometimes even smaller. You can indicate scale by placing your fairy or group of fairies against a flower, a leaf, or a spray of blossoms, or by including dewdrops, butterflies, and other insects familiar to the viewer.

FAIRY GARDENERS

✳ Since flower fairies are the gardeners of the fairy world, you can show them tending their own plants, perhaps sprinkling the roots with tiny watering cans, smoothing the ground with rakes, hoeing, or planting seeds. Some think that flower fairies spread the sparkling morning dew, too.

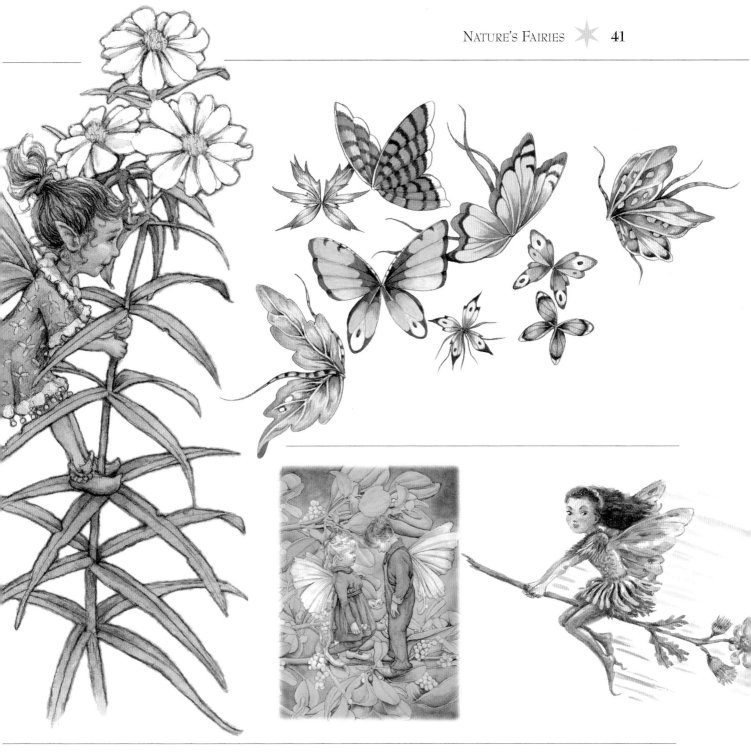

WINGS

✳ To indicate the type of fairy you are portraying, you can fashion wings from the related tree or plant; those of a willow fairy, for example, could be based on willow leaves. Some fairies might have wings of flower petals, autumn leaves, or leaf skeletons, while others might have butterfly or dragonfly wings. Try repeating the flower or leaf color on the wings.

MALE AND FEMALE

✳ The boys are round faced, cheeky, and mischievous, and dress in tunics and trousers, perhaps made from pressed leaves and multicolored petals. The girls are more delicate and wistful and extremely feminine. Some flower fairies have wings, while others do not, regardless of their gender.

GARDEN BOWERS

✳ Flower fairies can be found anywhere that flowers bloom, so they can be shown in a wide variety of habitats, from suburban yards with cultivated flowers to fields and meadows with wildflowers such as poppies and cornflowers, or shady woodland clearings with bluebells, anemones, and wild violets. Flower fairies also tend flowering trees in orchards.

Dryads: The Essentials

Dryads live only in those trees that grow in secluded places, far away from the prying eyes of men. Each has her own sapling and can merge with it at will, so that the chance passerby will see only a slender, graceful tree. The dryad has a very special relationship with her tree, and if it is cut down, she will die in the same instant. Nevertheless, on the night of the full moon, all the dryads leave their homes to dance together through the moonlit glades of the forest, and many a lonely shepherd has heard their silvery laughter.

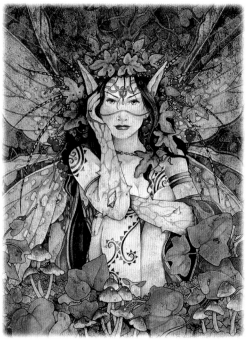

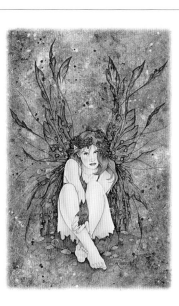

TREE NYMPHS

✴ Dryads are tree nymphs, and are always female, young, and lovely. The dryad's costume will be derived from the materials of her tree, perhaps with a bodice of bark or leaves, and necklaces of seeds and nuts. Her hair is threaded through with the leaves and twigs of her tree.

LEAF AND BRANCH

✴ The nymph and her tree are one and the same, so she may have pale skin like peeled bark, or smooth flesh the color of wood. Her silky hair is soft, and either leaf green or polished nut brown. Dryads are as tall and slender as young saplings, and just as lithe and supple.

TYPES OF DRYAD

✴ There are numerous classes of tree nymphs. The Meliads protect the ash, and the Maliades protect fruit trees. Hamadryads live within the oaks and Daphniai in laurels. Specific tree nymphs include Rhoea of the pomegranate, Helike the willow, Aigeiroi the black poplar, Ameploi the grape vine, Pteleai the elm, and Kraneia the cherry tree.

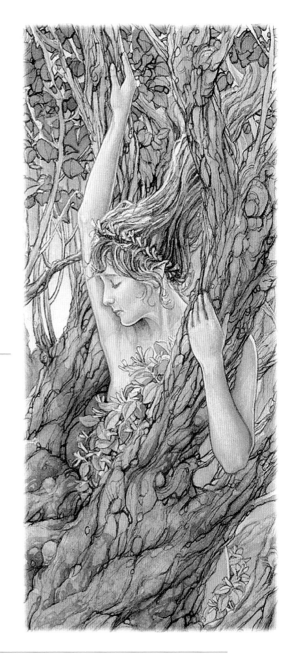

MOON MAGIC
✶ Like other fairies, dryads feel the irresistible enchantment of lunar magic on nights of the full moon. Beneath its pallid light, they leave their trees to dance together in woodland clearings, hand in hand, circling the forest floor. Sometimes human men have seen them, and have fallen in love with the beautiful creatures.

SECLUDED HABITAT
✶ Dryads are the daughters of the mountain gods, the Ourea, and sisters to the male Oxyloi, or woods. They only live in the inaccessible virgin forests that flank the mountains of their parents, where they are unlikely to be disturbed by the men who would cut down their trees and destroy them.

HAMADRYAD
✶ In Greek myth, Hamadryads are the nymphs of oak trees. They are usually pictured as female to the waist, while their lower parts are formed from the trunk and roots of the tree. Other dryads can be shown in the state of transition from humanoid fairy to a complete blending with their tree.

Nymphs: The Essentials

The lovely nymphs, who guard all the natural places of the earth, appear as young maidens, exquisitely beautiful, graceful, and charming. Their legends come to us from ancient Greece, where several different classes of such fairies were known, including the Potamids who made certain that rivers flowed freely, and the Naiads who ensured that the water of streams was fresh and clear. Oreads looked after the lofty mountain peaks, while Meliads were the nymphs of ash trees, and Dryads those of oaks. Oceanids dwelt in the sea and protected good sailors from shipwreck. Occasionally nymphs fall in love with human men, and their sons become remarkable heroes.

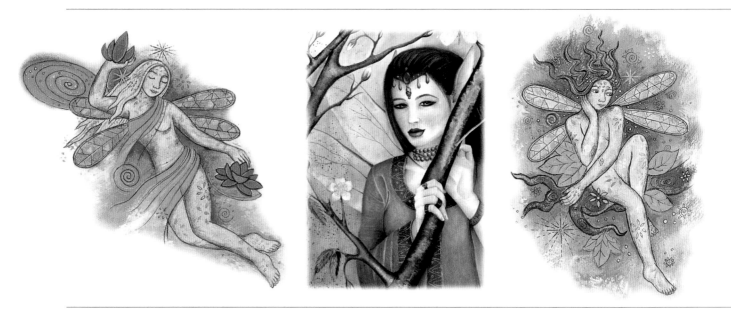

WATER NYMPHS
✴ There are several types of Hydriades—or water nymphs—named after the bodies of water they inhabit. The sinuous and powerful Potamids dwell in clear rivers, the bubbly Naiads guard running water and rippling streams, while the Oceanids, Haliai, and Nereids are the nymphs of the sea, the fish-tailed daughters of ocean gods.

BEAUTIFUL CREATURES
✴ Nymphs often intermarry with human beings. They are the same size as humans, and if they do not have wings, the lonely traveler in remote places, or the shepherd with his wandering flock, will not know whether he has encountered a magnificent fairy or a human girl of unearthly beauty.

EVERLASTING YOUTH
✴ The word nymph means "young girl" or "bride," and although nymphs live for thousands of years, they retain the appearance of adolescent girls for their entire lifespan. They are all dazzling in appearance, personifications of charm and femininity. They accompany the moon goddess Artemis as she hunts in untamed wildernesses.

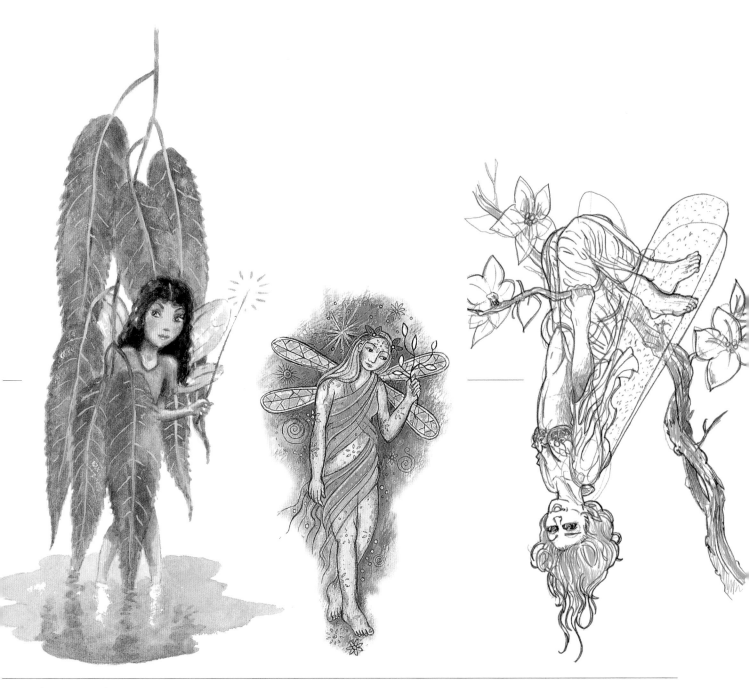

ELEMENTAL COSTUMES

✳ There are many different types of nymph, and they may adopt some element of their habitat in their dress, so that a dryad might wear a costume of tree bark and leaves, the Meliads crowns of winged ash, and Nephelai shining white dresses. Sea nymphs could wear blue-green outfits trimmed with white ocean spray.

LEGENDARY NYMPHS

✳ Nymphs have various responsibilities, including that of nurses to the gods. Those who fed the infant Zeus on honey are called Melissai, or "bees." In addition, there are the Aurai, nymphs of the breezes, the Lampades, torch-bearing nymphs of the underworld, and the Eleionomai of marshes. The Nephelai are spirits of the white mists or clouds.

PROTECTORS

✳ As protective spirits of all manifest nature, other nymphs tend to the animal and plant kingdoms, with dryads as the spirits of trees. In Greek mythology, Lampetia and Phaethousa are sun maidens, who care for sacred cattle, while in Roman lore, the Epimelian nymphs guard flocks of sheep.

Water Fairies: The Essentials

Every body of water, from the smallest stream to the vast ocean, has its own protective fairy living below the surface, and hoarding all the treasure from wrecked ships. Just as water takes the form of the vessel into which it is poured, water fairies have the power to alter their shape to suit their environment. If you anger them by polluting their water, they may appear as hideous green-toothed hags to drench you with a sudden storm, or drown you beneath the waves. But if they take a liking to you, they may appear as gorgeous, golden-haired youths or maids, wooing you with sweet fairy music.

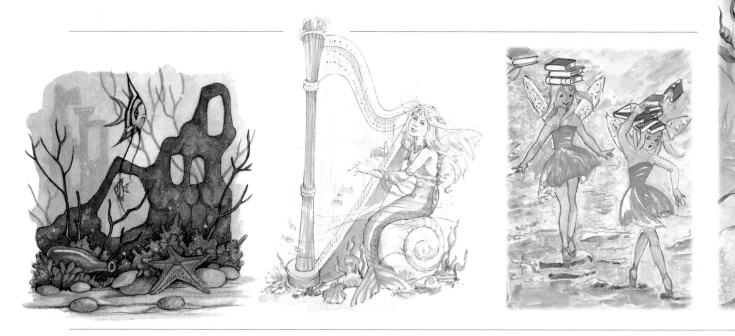

THE WATERY REALM

✷ In the silent blue depths, water fairies keep company with fishes and other denizens of the deep, such as crabs, lobsters, octopuses, and starfish. They ride sea horses or drive cowry-shell chariots drawn by dolphins and keep herds of white horses and cattle beneath the sea.

FAIRY MUSICIANS

✷ All water fairies have the power of musical enchantment, whether it is the sweet singing voices of mermaids and sirens, or the harps and fiddles of the nixies and nackens. Both males and females may appear sitting on a rock, singing and playing to attract sailors and human lovers into their watery kingdoms.

SEA SPIRITS

✷ Sea fairies may look entirely human, though there is always something in their appearance that suggests wetness; or they may have the upper torsos of humans and the tails of fish. They may also be naked, or dressed in green or blue. The females wear crowns of shells and spiky coral, and necklaces of pearls and amber.

COMPANIONS

✳ Water fairies are friends and protectors to all the underwater dwellers, from fish and turtles to porpoises. Fresh-water fairies may live in pools, lakes, streams, rivers, pools, waterfalls, watermills, and wells. Sea fairies live in underwater caves and grottos, or in sunken cities and palaces beneath the waves, carved from coral or crystal with streets paved with gold and silver stones, seashells, and amber.

PALE CREATURES

✳ Some water fairies appear as pale figures in the wraiths of mist that rise from lakes and rivers as the morning sun begins to warm the surface. Both males and females may be beautiful creatures with white, green, or blond hair. Their skin is pale or green-tinged from spending so much time beneath the water.

TREASURE

✳ All the treasure of sunken ships belongs to the water fairies. To find whatever gleams, they search the old wrecks at the bottom of the sea—the tall-masted sailing ships, rusting steamers, and modern liners that lie half buried in the sand—swimming through drowned portholes accompanied by shoals of fishes.

Sunflower Fairy *by Myrea Pettit*

The inspiration for this charming Sunflower Fairy came from the artist's young niece, who was photographed sitting in a tree. Children make wonderful subjects as they are so relaxed and supple in their positions, and sketching them from a series of photographs is the easy way to go about it. Don't ask them to pose—candid shots look much more natural.

1 Making any necessary adjustments to position and stance, lightly sketch the form in pencil onto bleedproof paper, adding the outline for your interpretation of wings. You can copy butterfly wings, or be inspired by the petals of the sunflowers. The fairy shape—with feet, hands, ears, hair, and clothes—begins to appear as a soft sketch, easy to adjust at this point with an eraser if needed.

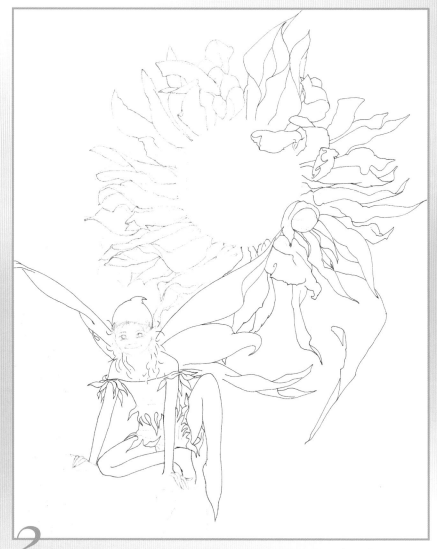

2 Once you are satisfied with the positioning and perspective, ink in the face, clothes, and hands with firmer but still soft lines. Carefully position the fairy on the bent head of a sunflower. Take note of how the petals twist and curl.

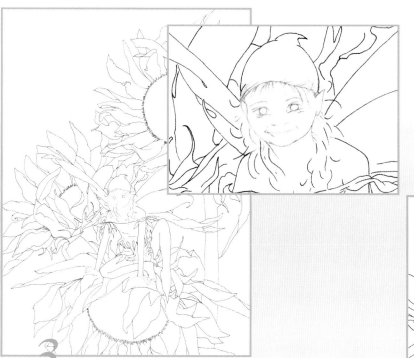

3 Ink the whole image with a fine outline, but retain the softness of the face, hands, and fingers. The bleedproof paper ensures that the ink will not run. Using artist's tape, cover the face, hands, and fingers so they are not smudged by the pencil as you work around them with a very fine black pen.

You cannot rush this process. You need patience and must be very steady with the ink pen as it cannot be erased—the only way to correct mistakes is to scrape with a sharp blade, which can damage the paper. Carefully ink the whole image.

Photocopy the picture onto watercolor paper for coloring. This is a necessary step so that the ink will not run into your watercolors.

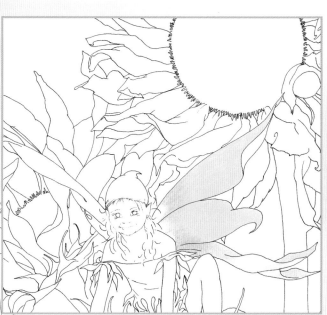

4 The fairy's wings are going to be a focal point of the picture, making a natural starting point. Apply a first base color of a cadmium and lemon yellow mix, laying a thin veil of color to express the delicate nature of the diaphanous wings.

Gradually add more of the yellow mix to give shape and shading, and then paint fine lines for the veins.

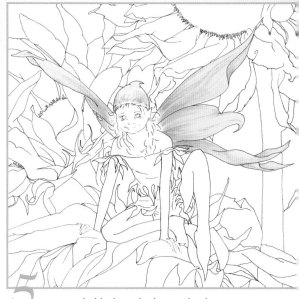

5 Tentatively block in the base color for the hat and skin tones so adjustments can be made and the areas of shading added later.

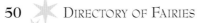

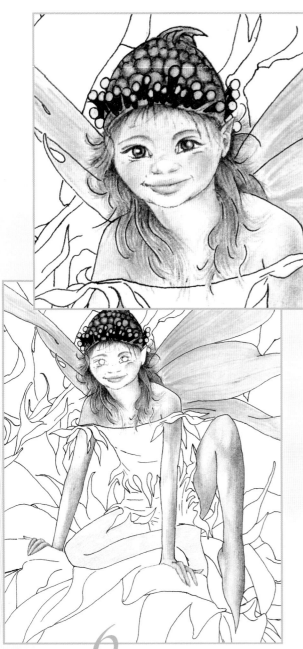

6 Gradually sketch in the hair and the facial expression, adding touches of alizarin crimson to the lips and cheeks. The seed heads on the hat can now be painted in sepia tones, and the first base color for the tights lightly applied using a mix of sap green and yellow ocher.

7 Create elf like legs by building up layers of sap green with shading in burnt umber, leaving highlights that reveal the leg shapes.

The first base color for the clothes can now be added, using the same color mixes as those for the hat and the wings. This shading with burnt umber is a continuous process, and you will need to make constant adjustments as you go along.

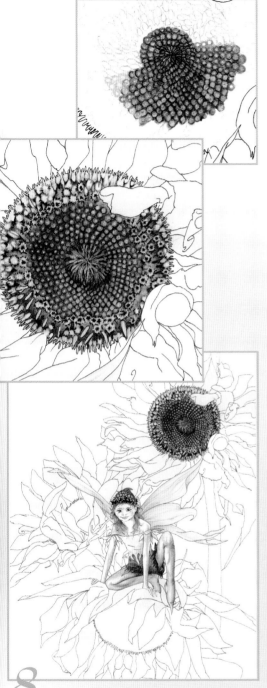

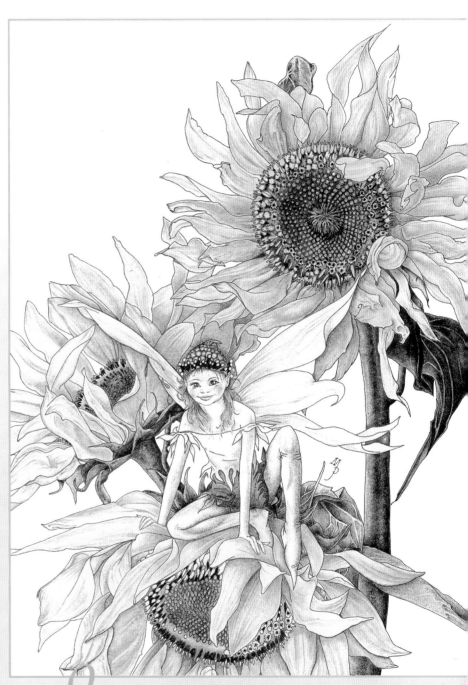

8 Apply a pale layer of cadmium yellow over the sunflower petals and centers. Add touches of sap green to the unripe seeds in the centers and then outline each seed using yellow ocher and a sepia wash, taking care to maintain the spiral pattern of the seed heads.

Build up the shading on the petals gradually, using shades of yellow ocher with touches of burnt umber. You need to bear in mind the direction of the light and imagine how the light and shade will flicker on the petals.

9 The flower heads now have form and definition. Paint the stems, sepals, and leaves with mixes of sap green, yellow ocher, and burnt umber and then add the final delicate detail, shading, and line work on the leaves and petals with very sharp watercolor pencils.

Peek-a-boo Fairy *by James Browne*

This fairy is based on a photograph of the model, observation of natural plant and flower forms, and the artist's imagination. A high viewpoint has been chosen so that we are looking down on the fairy, making the figure seem smaller in relation to the surrounding flowers and leaves. The painting is built up by alternating watercolor washes with pen and ink work, and highlights added with acrylic gesso.

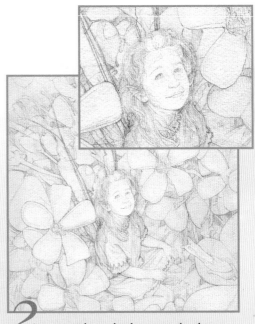

2 Mix a pale wash of sepia and indigo and, using a No. 10 brush, apply it over the whole image, working from top to bottom (see page 17) to neutralize the white of the paper. While the wash is wet, lift out highlight areas on the fairy and flowers by blotting with a paper towel (see page 23).

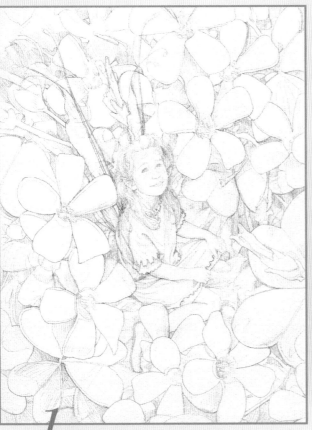

1 Working from reference material, such as sketches, use your imagination to work out your ideas. When you have achieved a satisfactory composition, draw it out on watercolor paper using a 4H pencil. Include details such as those in the hair, on the dress, and in the wings.

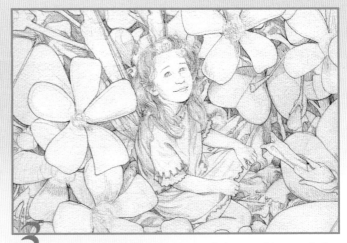

3 When the wash is dry, draw over all the pencil lines with the pen and sepia ink, varying the lines from thin to thick. If the ink appears too dark, tone it down by diluting with a little water.

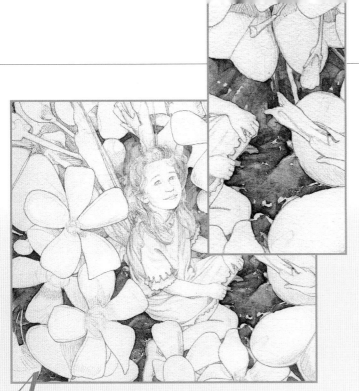

COLORS USED	
Cadmium Orange	Emerald Green
Alizarin Crimson	Hooker's Green
Permanent Rose	Sap Green
Mauve	Burnt Sienna
Dioxazine Violet	Sepia
Cobalt Blue	Indigo
Turquoise	White Acrylic Gesso

4 Using the large brush and mixtures of Hooker's green, turquoise, and burnt sienna, paint in the shapes of the shadow areas between the leaves, flowers, and fairy, leaving touches of the off-white paper so the ground does not appear flat and solid. The sepia ink will bleed into the watercolor washes to create a natural shadow. Drip tiny drops of clear water into the paint while still wet to add texture.

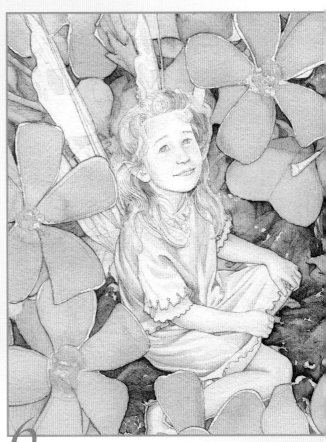

5 Paint the leaves, using a large brush, by laying thin, flat washes of a sap green, Hooker's green, and burnt sienna mix. Again, the sepia ink will bleed into the watercolor. Apply a flat wash to the petals, using mixtures of permanent rose, dioxazine violet, and turquoise. Keep the washes watery around the wings or lift off excess color with paper towels.

6 The form of the fairy is modeled with ink. Wet a No. 0 brush, pick up a little ink, and apply it around the contours of the fairy, in the shadow areas on her hair and face, under the chin, in the folds of the dress, and on the wings. The darker areas of shadow push the light ones forward to emphasize the forms—you can see this under the fairy's chin. If the ink is too warm in hue, drop in a little turquoise or indigo watercolor while still wet.

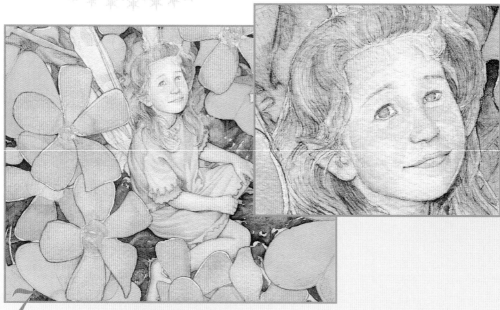

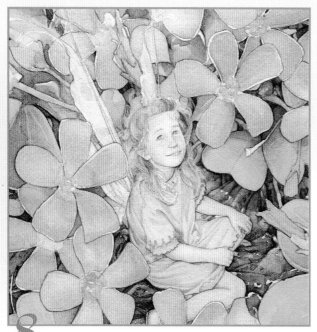

7 When the underpainting is dry, use a No. 2 brush and a mix of cadmium orange and permanent rose to apply a flat wash over all the areas of bare skin. Working wet into wet (see page 18), drop touches of alizarin crimson into the warmer areas, such as the cheeks, nose, ears, and hands. Add a cobalt blue wash over the dress and shoes, and a very dilute wash of the same color over the wings.

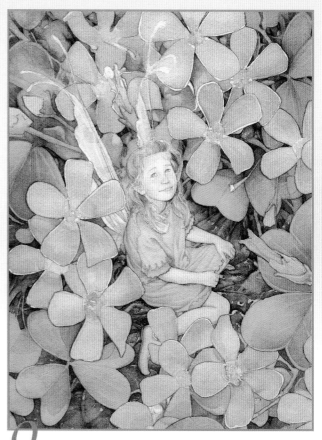

8 Add shadows to the flowers, using a No. 2 brush and washes of mauve, indigo, and burnt sienna. Keep the washes light and soft edged, and let them blend together in places. As when painting the fairy, use shadows on the petals to create depth, and repeat the process on the leaves, with Hooker's green and indigo. Create veins and highlights on the leaves by lifting off paint using a slightly damp brush (see page 23).

9 The glazing method (see page 20) is now used to lay additional layers of color over the whole painting. As watercolor is transparent, all the previous shading and modeling will be visible beneath the glazes.

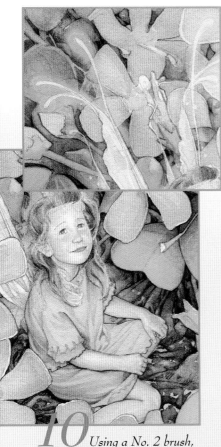

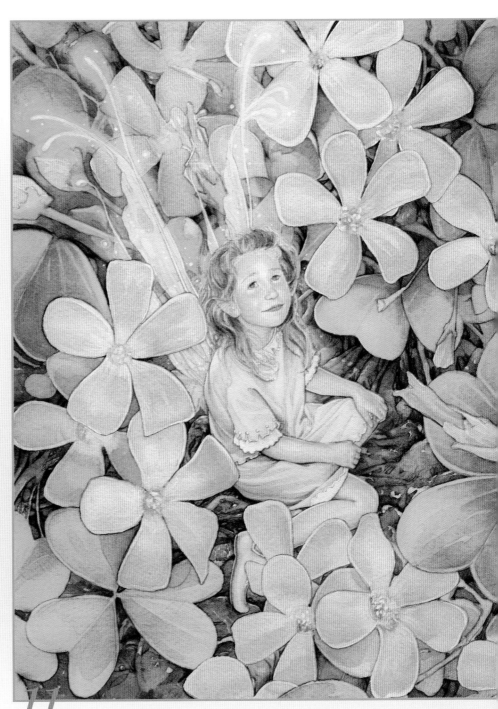

10 *Using a No. 2 brush, add more sepia ink in the shadow areas in the ground to "knock back" the vibrancy of the other colors and sharpen up the detail. Build up the form and color on the fairy using the same brush with small washes of alizarin crimson, cadmium orange, turquoise, permanent rose, mauve, and emerald green, and deepen the shadows on the dress with a stronger mix of blue with a touch of mauve.*

Use white acrylic gesso to add highlights, mixing it with watercolor where you want a pale color rather than pure white, such as on the wing tips and flower centers. Use white alone for the highlights on the fairy's clothing and wings.

11 *Apply further glazes over all the elements. Paint a gesso and pale blue wash over the wings. Finally, use white gesso for the specks of stardust around the wings, placing a small dot of paint and then encircling it with a thinner wash of watered gesso.*

ETHEREAL FAIRIES

All fairies are elusive, and are usually invisible to mortals, but some are more ethereal than others. Unlike the earth-bound nature fairies, ethereal fairies are closer to the world of spirit than matter.

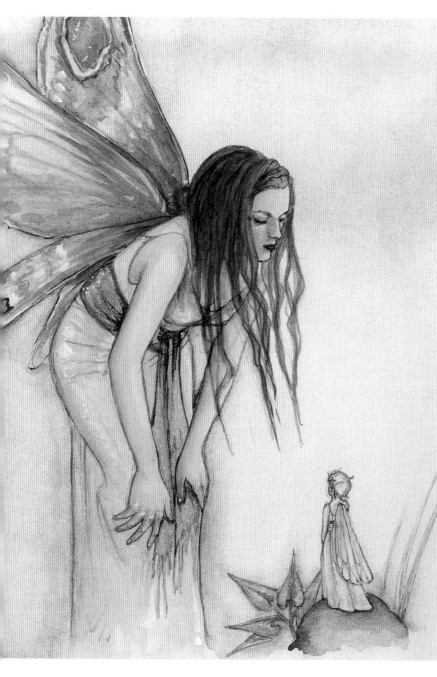

AUTUMN DANCE ✳ WENCHE SKJÖNDAL (above) The inspiration for this painting came from the sight of children frolicking in autumn leaves. The artist decided to take some leaves home and use them as a setting for this tiny playful sprite. The fairy was carefully drawn, but the handling of paint has been kept light and loose, giving a feeling of movement and excitement. The central leaf has a greater depth of color and detail than the surrounding ones, drawing the eye to it as well as the fairy suspended beneath it.

STUDY FOR A PIXIE ✳ JULIE BAROH (left) Two very different fairies come face to face here, illustrating the range of sizes and characteristics found in the fairy world. A Pixie Elder consoles the Littlest Pixie after she runs away. It was initially intended for the artist to work out the way the Pixie Elder would look, but the correct use of color and a well-balanced composition makes it come out rather well on its own.

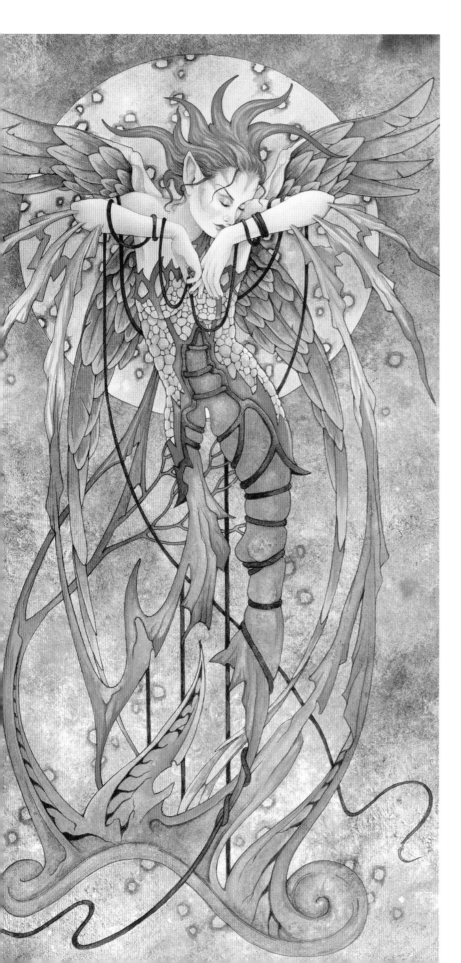

PHOENIX ✳ LINDA RAVENSCROFT (left)
As legend tells us, the fabulous phoenix is
reborn from the ashes of its own funeral
pyre. The artist has created a feeling of
upward-thrusting, blazing movement
through the use of sweeping curves and
greater concentration on detail in the top
third of the picture. The figure was drawn in
ink before the watercolor was applied, after
which the skin and upper section of the
figure were protected with masking film
while the rest of the image was painted over
with acrylic mixed with gel retarder, stippling
for texture. In the final stages, more detail
was added with watercolor and ink.

BRIANNE ✳ MEREDITH DILLMAN (above)
Initially sketched in pencil, the detailed drawing
of Brianne was finished with pen and ink. The
subtle painting in muted colors was then begun
in watercolor using wet paint on a dry ground,
reserving the white of the paper for the paler
areas. When this stage was finished, final
highlights and details were added with white
gouache. The trees were softly colored to
provide a suitable setting for the fairy queen
and her butterfly friends.

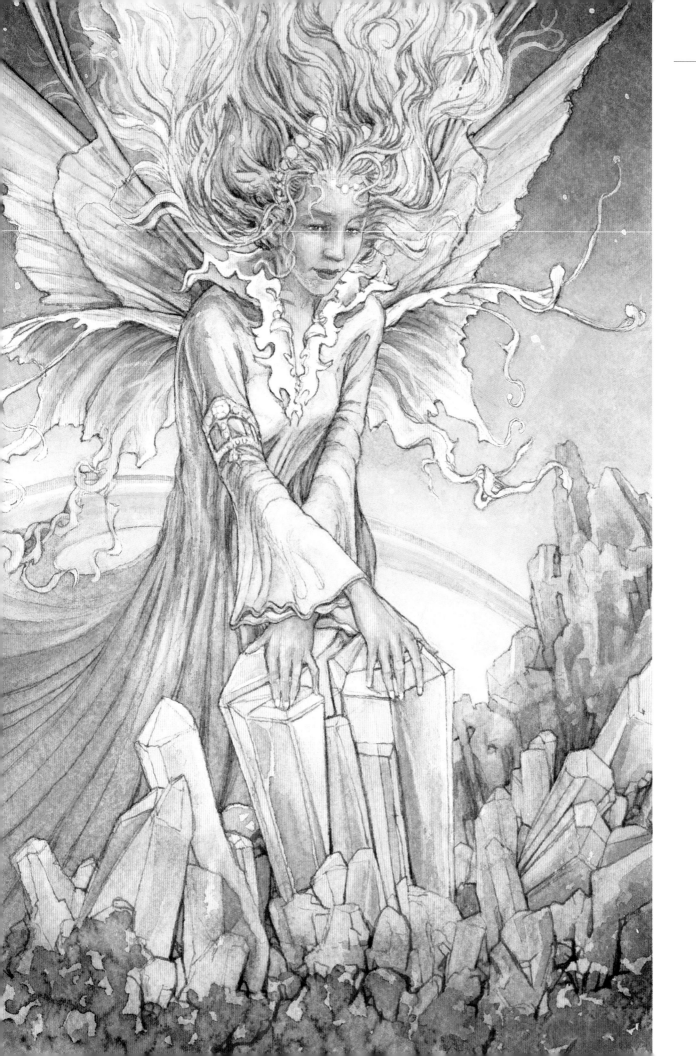

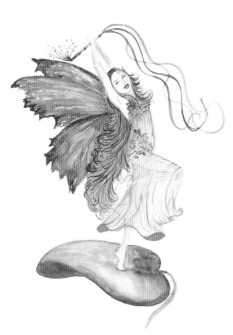

TORI—THE DANCING FAIRY ✳
MELISSA VALDEZ (above) The artist was
inspired by her love of music to create a
dancing fairy, with large wings like yards
of silk that sway behind her. The fairy was
sketched first, after which clear water was
painted directly onto the paper and color
added, guided into place with a fine brush
and encouraged to merge on the paper to
form new shades. This wet-into-wet layer
(see page 18) was then allowed to dry and
the painting was continued wet on dry in
a succession of layers.

THE RAINBOW FAIRY ✳
JAMES BROWNE (opposite)
Rainbows, seemingly magical in themselves,
are often associated with fairies. One of
the entrances to fairyland lies over the
rainbow bridge, guarded by the iridescent
Rainbow Fairy, who is the subject of this
painting. Her fine flying hair and wispy
wings give the impression of airiness, while
the blues and grays of the sky suggest the
mixture of rain and sunshine required to
form the rainbow. The figure was drawn in
waterproof sepia ink and the background
was achieved with wet-into-wet washes,
with the lighter areas around the figure
lifted out while the paint was still wet.

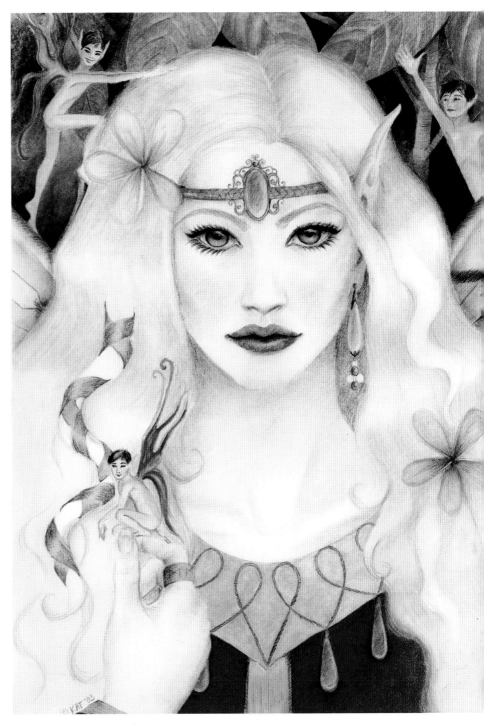

MAB ✳ KIM TURNER (above)
This softly luminous work, reminiscent of the Pre-Raphaelite painters, was created
with layers of watercolor and colored pencils. Mab is the queen of the fairy court
near Shakespeare's birthplace, Stratford-upon-Avon in central England.
Shakespeare said that Mab delivered men of their innermost wishes in the form of
dreams, and that when she roves through lovers' brains they dream of love; when
she passes over courtiers' knees they dream of courtesies; when she passes over
lawyers' fingers they dream of fees; and when she passes over the lips of ladies they
dream of kisses.

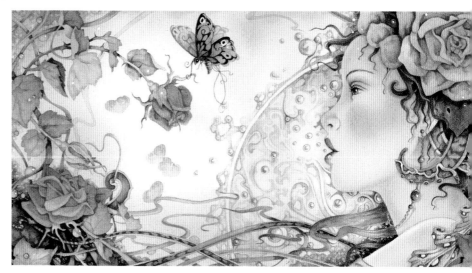

OXYGEN ✷ LINDA RAVENSCROFT
(above) The inspiration for this
picture sprang from the artist's
concerns about air pollution, and
she decided to produce an image
that celebrates fresh air and suggests
how precious it is. The beautiful
creatures shown are sylphs, who live
entirely in the element of air. The
painting has been given additional
impact by doubling the image, with
two sylphs placed back to back,
though there are subtle differences
between the two halves, such as the
position of the butterflies and the
coloring of the leaves and flowers.

FAIRY MOON ✷ JESSICA GALBRETH
(left) The bright nights of the full
moon are a favorite time for fairies,
and it is on such nights that they are
most often seen dancing in shady
forest glades. The artist has used
strong tonal contrasts and a limited
palette of cool colors to suggest the
moonlight that bathes the figure of
this elegant and pensive fairy. The
crystallized texture of the background
was produced by laying wet washes of
blues and purples and then scattering
in substantial quantities of salt.
Well-diluted washes of blue were
used for the fairy's dress and wings,
and final highlights were added with
white gouache.

AIRDANCE ✳ BRIGID ASHWOOD
(below) The sense of movement in this painting is emphasized by those elements of the picture that seem to be flying out of the frame. These include the butterfly in the top left-hand corner, the dragonfly below it, and the leaves in the bottom left-hand corner. The sylph herself reaches forward and looks like she is about to rapidly fly away from us. Additional interest is created by decoratively fragmenting the frame.

Sylphs: The Essentials

Sylphs dwell entirely in the element of air, riding the wind thermals and resting occasionally on high mountain summits. They are almost transparent to those who do not have the "fairy sight," but you may feel their passing on drafts and puffs of air, or if you listen carefully you may hear their voices on the breeze. Their name comes from a Greek word meaning "butterfly," and some sylphs have the wings of butterflies while others have feathered wings like birds. Some are very tall, and others as tiny as moths, but all have eyes as sharp as those of hawks.

FACIAL FEATURES

✴ Sylphs have long, angular faces and large, piercing gold-rimmed black eyes, which some say resemble those of a hawk or falcon. The bird connection can be emphasized in their costumes, which could be constructed from feathers such as fluffy white swan's down or elegant gray pigeon plumes.

AIRY REALMS

✴ Sylphs do not like to fly too near to the ground, but prefer to remain in the upper regions of the earth's atmosphere, or near the pure, cold summits of mountains and high peaks. These places suit their airy temperaments and give them the quiet they need to develop their thoughts and creative abilities.

BUTTERFLY OR FEATHER WINGS

✴ Sylphs are buoyant creatures of the air and are always winged. Some have the delicate wings of butterflies or moths, for which you might adapt those of large, exotic *Lepidoptera*. Others have long feathered wings, which could be based on those of birds—striped hawk feathers, brightly colored parrot feathers, or gleaming blue-black crow feathers.

FAIRY FRIENDS

✳ Sylphs never touch the ground but remain airborne in the company of other flying creatures. Their particular allies include butterflies and moths, swooping birds like swallows, and swift-striking birds of prey, especially hawks, falcons, and eagles. Sylphs share their avian friends' ability to hover on the wind and ride air thermals.

GRACE AND CHARM

✳ Sylphs vary in size from tiny creatures hardly bigger than moths to impressive beings much larger than humans, but they are always slight and pale, sometimes even appearing semitransparent. They are svelte, graceful creatures who never seem to age, even though they live for hundreds of years.

WIND POWER

✳ Sylphs are the masters of the element of air. They are ruled by King Paralda, who has power over all the winds of the north, south, east, and west. He can bind the wind with magic knots or release the winds when needed by letting them loose from the leather sacks where they are kept.

Sprites: The Essentials

Sprites are insubstantial and subtle beings. Their name simply means "spirit," and they have few dealings with mortals. In popular fairy tales, sprites are responsible for ushering in the winter, causing the leaves to change in the fall, turning them brown, red, and gold before they wither and drop from the trees. Other sprites appear as spirits of frost and snow, painting windowpanes with lacy ice patterns and nipping the fingers and toes of children. Sprites are always out when sun and rain occur together, and the rainbow bridges the gap between the ordinary world and fairyland. It is the sprites who paint it with its seven colors.

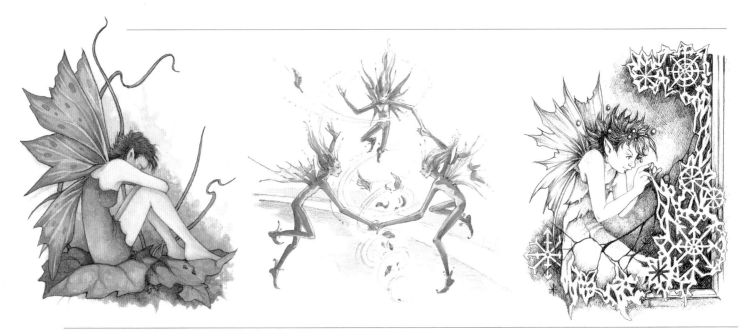

IMAGINATIVE WINGS

✳ The wings of sprites can vary according to the type of sprite you are representing. An autumn sprite could have wings made from leaves in their fall colors, while a rainbow sprite might have iridescent wings reflecting the colors of the rainbow. A winter sprite would have wings glistening like ice, or patterned like snowflakes.

ETHEREAL CREATURES

✳ Although sprites have the important task of changing the seasons and the weather, they are very slight, delicate, and fragile, sometimes almost wraithlike and semitransparent. They may appear alone or in groups, working or playing and frolicking together.

MAKING LACY ICE PATTERNS

✳ Sprites are tiny nature fairies associated with weather and the seasons. Frost sprites bring cold, snow, and frost to the world, so take your cue from the winter landscape to portray them dressed in white, blue, or silver costumes, wearing icicle caps or snowflake crowns. They may be transparent, or be formed by flurries of snow. Add frosty sparkles to their wings.

AUTUMN LEAVES

✳ Autumnal sprites can be shown tumbling playfully among the falling leaves, wearing the red, orange, ocher, bronze, copper, brown, and gold colors of the season. Their hats and caps are formed from red hawthorne berries, rosehips, or blackberries. Wings can be fashioned from sycamore and ash seeds; dried, crumpled leaves; or leaf skeletons.

THE FAIRY ARTIST

✳ Jack Frost is the winter sprite who scatters ice in his wake, spreading glittering frost over every leaf of a tree and each individual blade of grass. He works at night, painting cold windowpanes with elaborate frozen, lacy patterns, and making ordinary pavements sparkle like diamonds. He dresses entirely in white, with icicles dripping from his clothes.

RAINBOWS

✳ When sun and rain occur together, sprites create the rainbow across the heavens. You might take this literally and show them with pigment and palettes painting the sky, or show the bridge to fairyland becoming visible in the unearthly light. A rainbow sprite might be seen wearing just one—or all—of the colors of the rainbow.

Devas: The Essentials

Devas are rather esoteric fairies that occupy a mystical realm between the physical and spiritual plane, which is therefore sometimes referred to as "The Middle Kingdom." They are ethereal creatures, with bodies made of the very finest matter that seem to shine with an inner light. The energy that flows through them sometimes appears as flowing hair and wings, though they can take any form they wish. Their job is to give the world its material structure and especially to show plants how to grow and what form to take. Every plant, flower, and vegetable has its own deva.

LUMINOUS BEINGS

✳ Devas are luminous beings. The term comes from a Sanskrit word meaning "body of light," and psychics may perceive devas as a spark of luminosity within the heart of a plant, or as a glowing aura around it. Though the terms flower fairies and devas are sometimes used interchangeably, devas are really beings of pure energy.

WINGED FAIRIES

✳ Devas are nonphysical, high-vibrational beings. Their most commonly observed form is a glowing ball or ribbon of light, though they may take any shape they like, reflecting the preconceptions of the spectator. Humans often perceive them as winged fairies—very slender, radiant, and semitransparent.

ENERGY

✳ The task of the devas is to transmute energy into matter. They are never still, and their movement creates sounds, vibrating waves, and energy patterns, coalescing energy into physical matter. This work is not restricted to the plant kingdom, but also applies to animals, rocks, crystals, stones, and entire landscapes.

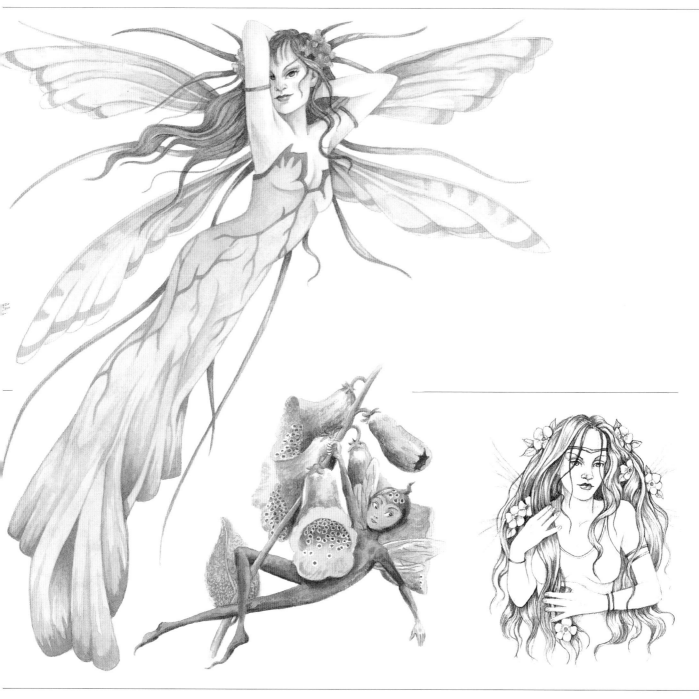

INCORPORATING MOVEMENT

✳ To show the devas' role as whirling energy, try to incorporate movement into your painting. Make use of a dynamic pose for the fairy itself, and think about the repeating rhythms of music when planning the composition, making use of upward curves and spirals, clusters of swirling dots and coils, and splashes of pale colors.

PLANTS

✳ Devas provide the template for the form of a plant and then encourage it to grow. There is a deva for every type of plant, so there is a foxglove deva, a strawberry deva, a marigold deva, and so on. Some say that there are separate devas for blossoms, leaves, and fruit, each having its own task.

FLOWING LIGHT

✳ To emphasize the devas' nature as beings of light, try giving them long, flowing bright hair, pale diaphanous wings streaming behind them, and wispy, fluid garments. Devas are sometimes semitransparent or partially materialized within their plant or mineral.

Song Fairy *by Stephanie Pui-Mun Law*

A twisting arch of gnarled wood provides the basis for the composition, with several varied elements and forms built up on it. The image gives a strong feeling of movement, with the eye drawn upward from the lower left and through the arch with its small fairies to the Song Fairy herself. There is an attractive contrast between the loosely worked background and the fine detailing in the figures and other elements.

1 Sketch the composition onto the paper or illustration board using a 2B pencil, taking care not to make indentations. Light pencil lines on a smooth surface such as illustration board will eventually be rubbed away by brushstrokes and the side of your hand, but you can fix the pencil marks if you wish by swiping quickly across the relevant areas with a large brush loaded with water. Lightly dab off the excess.

Using an old brush, dot some little blobs of masking fluid (see page 14) in the background around the fairy wings and in the sky. These spots of reserved white paper will add sparkle. Mix a wash of lemon yellow and sap green, and carefully paint around the fairies, diluting the color as you paint up to the outlines. Leave the fairies white for now.

2 Make a watery mixture of sap green, viridian, and a little purple lake, and apply it to the background using a No. 10 round brush. Toward the top, add a little more purple lake and burnt umber to the mix. As you work up to the original yellow wash, dilute the new color and blend it into the yellow, dabbing away excess liquid with a paper towel.

Keep adding light washes of viridian and sap green to the background, working wet into wet (see page 18) to increase the intensity of the color, and blotting or lifting off (see page 23) in places to create lighter areas.

3 For the darkest crevices in the arch use a mixture of Payne's gray and burnt umber and a No. 2 brush. For the shadows beneath it, use burnt umber and Prussian blue, which makes a dark greenish hue that works well for the leaves. Add some shadowy branches and leaves in the background using a mixture of viridian and a touch of Prussian blue, feathering the color into the surrounding greens by softening the edges with a dry brush.

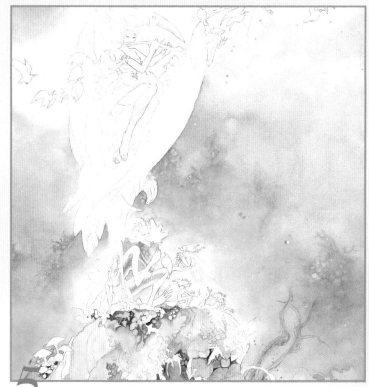

4 Paint in some more shadowy trees and branches in the background using a mixture of viridian and purple lake. The mottled effect is created by taking a small damp brush and lifting out some of the color (see page 23). Keep the edges soft by working with dilute washes.

5 Using a No. 4 brush, apply a wash of burnt umber on the left side of the arch and a mixture of purple lake and ultramarine blue on the right, working around the mushroom shapes. Give the leaves a base wash of sap green and lemon yellow, and the seated goblin a base of viridian and purple lake. With a No. 2 brush, add details to some of the background branches by outlining the edges and defining the bark with viridian. Now begin to paint the main fairy, starting by laying a flat wash of Chinese white, alizarin crimson, raw umber, and cadmium yellow over the skin areas.

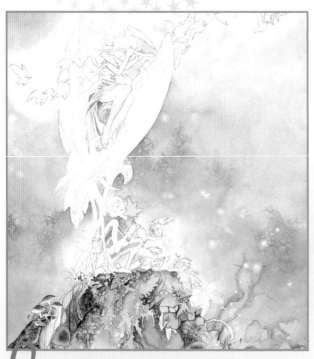

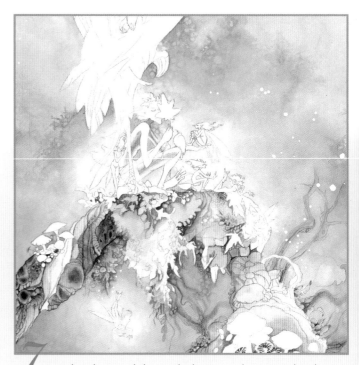

6 When all the previous washes are dry, remove the masking fluid. Continue adding detail to the archway with a No. 0 brush, and outline the cracks with a mix of ultramarine blue and burnt umber. Use burnt sienna and light red to deepen the blue tones on the left side, and ultramarine blue and purple lake to add shadows. Darken the heart of each leaf slightly with a little sap green. As you work toward the light, glowing areas, mix some yellow ocher into the wash.

7 Gently rub around the masked areas with a No. 1 brush and a little water to lift off some of the green and soften the glow around the sparks. Blend the tops of the mushrooms using variations of cadmium red, alizarin crimson, and cadmium orange. Then continue to add detail to the arch with the smallest brush, edging the cracks to deepen them and lifting off color (see page 23) in places to add more texture. Add more depth to the leaves under the arch with a mixture of viridian and yellow ocher.

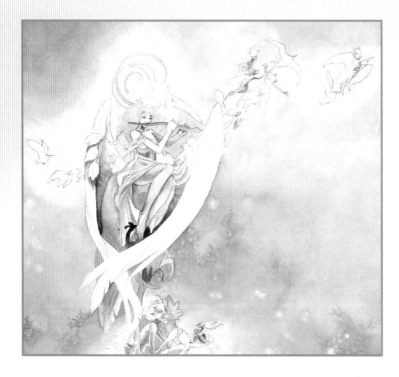

8 Lay a wash of ultramarine blue on the Song Fairy's dress. Add shadows to her flesh using burnt umber and a No. 4 brush, and when the first color for the dress is dry, add a light wash of Chinese white and sap green to soften the shadows. Use raw umber and alizarin crimson for the sash, and cadmium orange and lemon yellow for both the base wash on the hair and the bird's legs.

Paint shadows on the bird with a No. 2 brush and a mixture of purple lake and ultramarine blue. In the very darkest areas, add a mixture of Payne's gray and burnt umber. Leave the edges of the fairies' bodies white, concentrating the color and shadows down the centers.

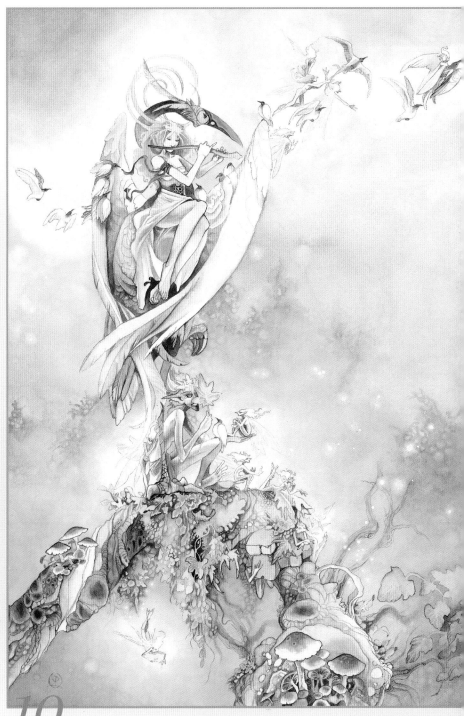

9 Using cadmium red and a No. 1 brush, add depth to the hair by painting the shadow shapes around the light areas. For the ribbon and the feet and heads of the birds, use a mixture of cadmium red and alizarin crimson, blending it across the birds' bodies, leaving white paper showing for the eyes. Outline the bottom of the Song Fairy's skirt in red with a No. 0 brush, and outline the edges of the bird's back feathers with Payne's gray, blending the line outward.

For the fairies' wings, use combinations of sap green, lemon yellow, and cadmium yellow, leaving flecks of white to give the impression of veining.

10 To complete the painting, add little specks of highlight with opaque titanium white along the bottom edges of the large bird's back feathers, as well as on its textured standing foot, along the edge of the beak, and on the Song Fairy's toenails. Finally, add tiny ivory black specks to the centers of the small birds' eyes, taking care to leave some white around the dots.

Dark Eyes Fairy *by Linda Ravenscroft*

The reference for this fairy, who has a largely human form, was a photograph of a model. The bed of ivy on which she sits, and the leaves and berries in her headdress, are based on observations and studies of natural forms and colors. When you are walking in the woods, imagine what everything would look like from a fairy's viewpoint, and make sketches or take photographs for use as reference.

2 Outline the figure with pen and waterproof ink. Ink in the eyes and eyebrows, but leave the rest of the face sketched in pencil. Ink in the main outline of the hair, leaving the shaded areas in pencil. Ink in the outlines of the leaves and the wings. Darken the remaining pencil lines so more detail shows in the tattoos and sleeves.

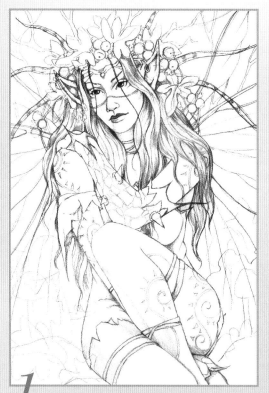

1 Sketch the figure onto the working surface using an HB pencil, avoiding hard pressure as you will need to remove the lines later. Pay special attention to the face and the expression. When you are sure you have drawn the figure correctly, add the outline of the wings and headdress. You can make these up or refer to sketches or reference books. Roughly sketch in the tattoos, leaves, toadstools, and twigs, adding some pencil shading to provide a little modeling.

3 Using a No. 0 brush and a mix of sepia and raw umber, add color to the eyes and skin and some of the darker areas of the hair. The light source is slightly in front of the image in the top right-hand corner, so the shadows fall on the left side. Paint the lips with scarlet lake mixed with a little raw umber, and still using the fine brush, paint the pupils with burnt sienna.

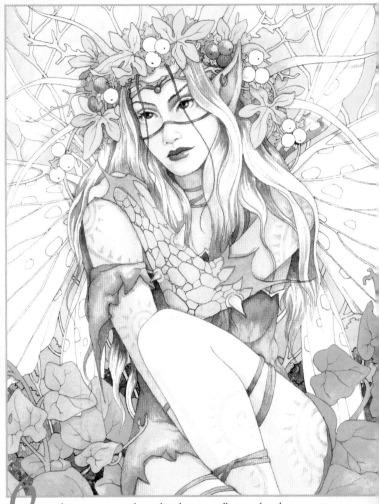

COLORS USED

Cadmium Yellow	Burnt Sienna
Scarlet Lake	Sepia
Cadmium Red	Payne's Gray
Purple Madder	Lamp Black
Viridian	Zinc White Gouache
Olive Green	Raw Umber Acrylic
Raw Umber	Olive Green Acrylic

4 *Continue to model the head with the small brush and washes of sepia mixed with a little lamp black. Gradually build up darker tones in the eye sockets, the ear, the shadows in the hair, and around the neck. Then use olive green washes to define the leaves and viridian for the inner foliage on the headdress. Remove some of the pencil lines in the headdress with a soft eraser to see how it is looking, but don't worry if there are gaps—you can add more foliage and twigs later. Fill in the ivy with a No. 4 brush and a wash of viridian with a touch of olive green, blotting the edges of some of the leaves with a small piece of paper towel to soften them.*

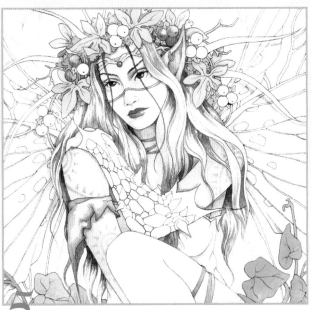

5 *Mix two separate dilute washes of cadmium yellow and cadmium red, and add hints of color to a few of the berries. Place a small spot of yellow in the middle and then add the red around it, letting the colors bleed together. Blot with tissue. Using the No. 4 brush and a mix of raw umber and a little sepia, lay a flat wash over all the areas of skin. While still damp, add more of the same color to the shaded areas on the left side of the figure to give the form more definition.*

6 *Apply separate washes of cadmium yellow and cadmium red to the dress. Add a wash of olive green to the sleeve, with touches of cadmium red along the edges, and then paint the cuffs and the bands across the face with a wash of Payne's gray. With a No. 1 brush and varying strengths of olive green, fill in the background, applying darker washes at the bottom for the shading behind the ivy and graduating up to a lighter wash at the top.*

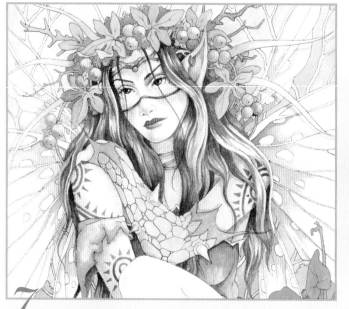

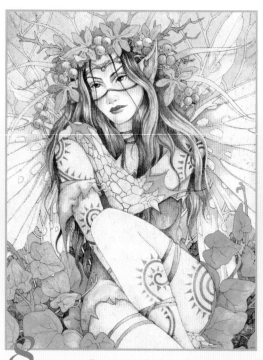

7 Give some extra form to the hair by adding lowlights with lamp black mixed with a little Payne's gray. When dry, remove any unwanted pencil lines with a soft eraser. Continue to build up detail, using a mixture of cadmium yellow and olive green for the twigs in the headdress, and washes of cadmium yellow and cadmium red for the berries. Use these colors again for the dress and sleeves to model the figure, and then change to scarlet lake to add color to the cheeks, nose, and forehead; the top of the arms; the chest; and the shadows of the skin.

8 Mix a small amount of raw umber acrylic and olive green acrylic with a larger amount of gel retarder. (It is best to experiment first on scrap paper.) Then paint over the whole image with a large bristle brush. The retarder will keep the paint workable for some time, so once you have applied it you can work with a stipple/stabbing action all over the painting, dabbing with tissue over areas that might be too dark. This stage is optional, but is worth trying out, as it creates a wonderful texture.

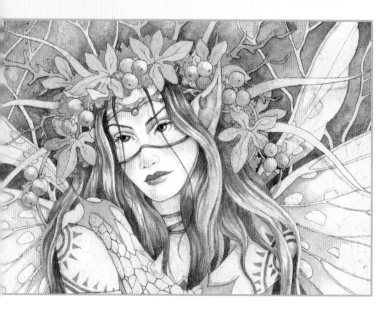

9 When the acrylic layer is dry, lay a wash of purple madder over the background with a No. 4 brush, remembering the areas between the lower sections of the wings. The wash stays wet for longer on the acrylic surface than it would if used on bare paper, allowing you to lift out color (see page 23) with tissue to create subtle graduated effects. Continue to add washes until you are happy with the depth of shadow, keeping the colors darker around the figure and the edges of the painting.

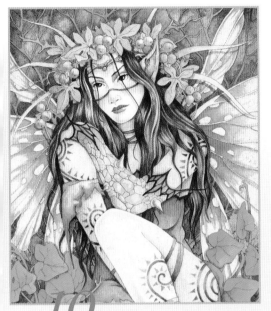

10 Using a No. 0 brush and viridian, paint in the twigs in the background, and then change to the No. 4 brush to add more viridian to the ivy leaves and headdress. Build up the colors in the dress and adornments, working wet into wet (see page 18) with the same colors as before, and adding a little extra red at the tips of the sleeves. Strengthen the wings with more washes of the colors used earlier, and add more detail around the edges. Work into the shadow areas of the hair with lamp black mixed with Payne's gray.

Continue to paint washes of yellow and red on the wings, dress, and berries until you are happy with the density of color. Re-outline most of the painting with the pen, reinstating any lost details and adding some extras, such as the stripes on the protrusions on the headdress and the detail on the sleeves.

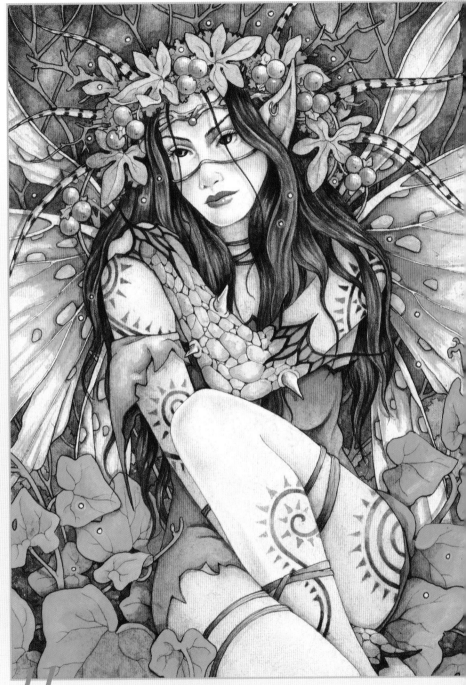

11 Paint highlights on the eyes and lips with the zinc white gouache, and make tiny blobs of pure white surrounded by a halo of diluted white for each of the little specks of pollen or fairy dust. Dilute the zinc white gouache to paint diffused highlights on the ivy leaves. Finally, add a little more purple madder to the background, and brighten up some of the clothing with stronger washes of the previous colors.

DARK FAIRIES

Not all fairies are good and beautiful. Some are ugly, and some are very wicked indeed, with their chief aim in life being the suffering of human beings.

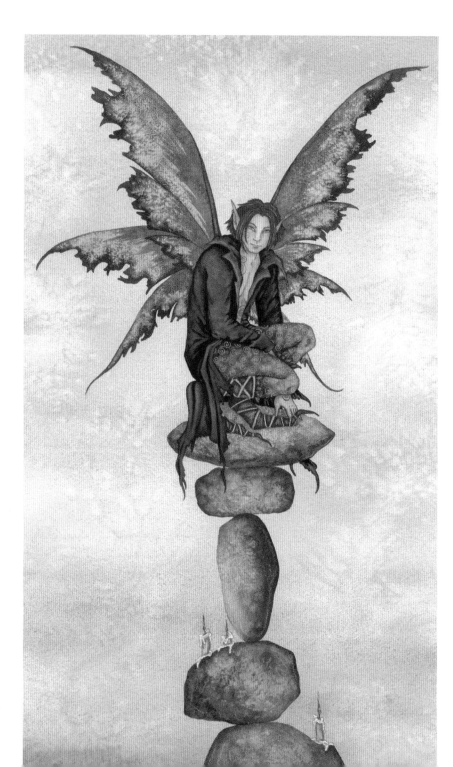

THE THIEF ✶ BRIGID ASHWOOD (above)
This fairy thief may be either a scheming temptress who will take your last penny or a female Robin Hood, who takes from the rich to give to the poor. Some fairies are certainly known to be thieves, but only take away what selfish humans deserve to lose; when people become miserly and refuse to share their possessions, the fairies will take them. The fine details in this picture, notably around the eyes, were created with colored pencils. Additional shadows on the stones and surrounding frame and wing segments were achieved with white gouache and gray watercolor marker.

NIMBLE JACK ✶ AMY BROWN (left)
The artist has chosen a tall vertical format for this painting in order to draw the eye upward to the mischievous-looking fairy perched on top of a precarious-looking pile of rocks. To paint the stones, she blocked in the shadows first, using layers of Payne's gray mixed with lamp black. To achieve the granular effect, salt was sprinkled into the wet paint, and then some light scribbling with a watercolor pencil was added over the top for highlights in the stone. All the colors in the composition are harmonious earth tones of green, gray, umber, and brown.

ARACHNE ✳ JACQUELINE COLLEN-TARROLLY (left)
In Greek myth, Arachne was a weaver who unwisely boasted that her work was better than that of the goddess Athena. The offended goddess retaliated by turning her into a spider so that she must spin forever. The striking white web in this painting was begun by using the impressing technique, which involves drawing with heavy pressure, using a white pencil, so that the linear indentations show through the background wash. The lines were later reinforced with a fine brush and white paint, varying the strength of the paint to achieve lighter and darker areas that give the feel of the delicate, almost transparent silk.

CHARMS ✳ MARIA J. WILLIAM (below)
The glowing stars in this malevolent-looking goblin's hands give an intimation that a magic spell is being cast, and it is plain that it is not a benevolent one. In the past, many diseases and disasters were attributed to the malign interference of fairies. Rheumatism, cramps, and bruising were considered a punishment for annoying them, while the invisible presence of a fairy market might cause paralysis in an inadvertent trespasser. The glowing effect of the wings in this image was digitally added to the painting using a computer graphics program.

THE FROST QUEEN ✴ BRIGID ASHWOOD (right)
This is one of a series of portraits of fairy royalty,
imagined by the artist as having accidentally fallen into
human hands. She found the frame in a second-hand
shop and painted it with a *trompe l'oeil* ("fool the eye")
technique so that it appears to be studded with precious
gemstones. Areas of the painting itself were softened to
create the foggy effect of the castle in the distance, and
the same method was used to add the highlights on the
crown, jewels, eyes, and hair. By using a palette of cool
colors, the artist has created a moody portrait that
evokes the icy emotions of her subject.

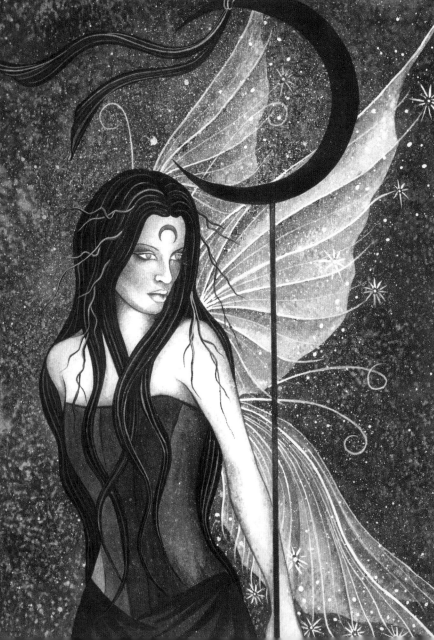

MORGAINE ✴ JESSICA GALBRETH (left)
Morgaine has her origins in Celtic mythology.
She is a dark fairy queen, also known as Morgan
le Fay, or Morgan the Fairy. She is mistress of
magic and ruler of Avalon, the mysterious island
where old age and death are unknown. It was to
Avalon that she transported her half-brother
Arthur as he lay dying after his final battle. She
cured him with her magic, and he lies sleeping
until the day when Britain shall need him again.
The monochromatic treatment and bold tonal
contrasts give a strong sense of drama in keeping
with the subject of the painting.

ROOK ✳ AMY BROWN
(right) This handsome,
dandified fairy looks
distinctly dangerous, an
impression enhanced by
his crow-feather wings
and the sinister black
butterflies. The
background was painted
first, with several layers
of very dilute paint
applied with a large
brush, each layer being
allowed to dry before
the next was added. The
tower edge was painted
in raw umber, burnt
umber, and titanium
yellow, with the mottled
effect achieved by
sprinkling salt on to
the paper while the
paint was still wet. The
figure and butterflies
were painted wet on
dry over the completed
background.

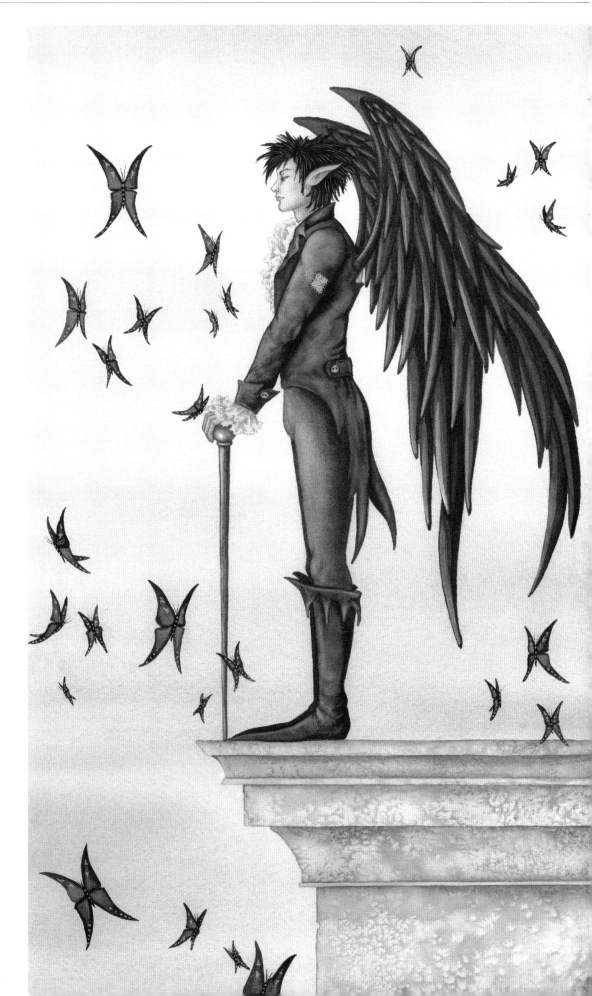

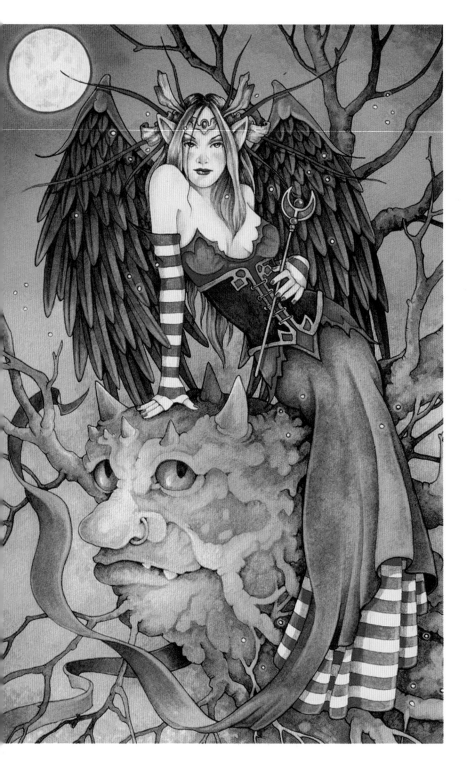

THE GOBLIN TREE ✶ LINDA RAVENSCROFT
(left) The vibrant blues of this fairy's gown and
feathered wings give the impression of strength
and confidence, and her pose is self-assured,
perhaps even challenging. She is seen in the light
of a full moon, perched on a goblin tree, the face
of which the artist has constructed with great
ingenuity. It grows out of the tree bole, and its
threatening appearance is enhanced by the spiky
twigs and bark that surround it. Masking fluid
was applied to the moon to reserve it as white
paper while gray and blue washes were painted
over the sky area.

SPRING FAE ✶ JESSICA GALBRETH (below)
This sensuous spring fairy strikes a seductive and
provocative pose, giving us the impression that
she knows what she wants. A script/liner brush
and black paint were used to outline many of the
objects in this picture, such as the window, as well
as to create the twining vines. Vibrant flower
colors were used for the wings, the body, and the
floral brassiere.

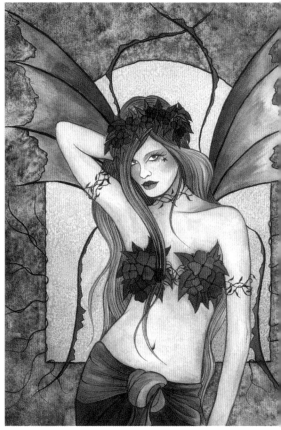

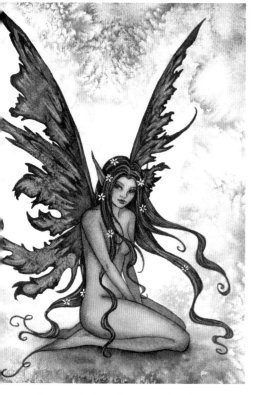

FLORA ✳ AMY BROWN (above)
Simple, strong colors establish a sense of
power and presence in this painting, while
the swirling backdrop adds movement,
which is echoed in the twirling shapes of
the fairy's wings. To create the background,
purple and blue tones were mixed on the
paper, and then water and salt were added
to create texture. Color was blotted out in
the area of the figure, which was painted in
when the background was dry.

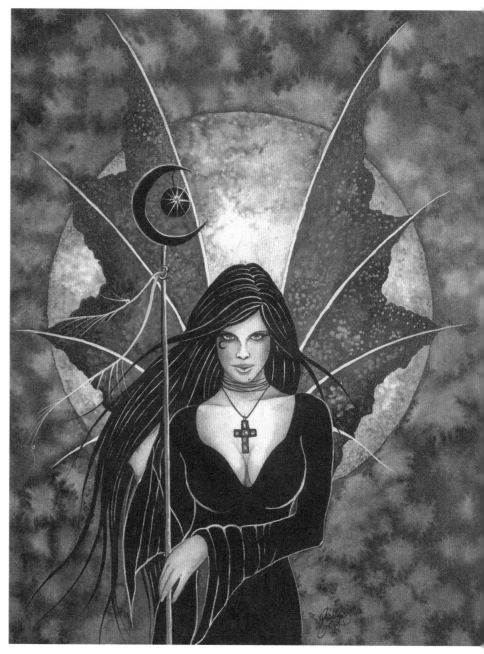

GOTHIC FAIRY ✳ JESSICA GALBRETH (above)
This fairy may be dark and decadent, but she is also
seductive and extremely feminine. The starburst effect
in the sky behind the figure was created by dropping
clear water into still-damp washes of purples and grays,
using a large brush. A thick wash of black watercolor
was used for the fairy's dark hair and dress, and the
highlights in her hair and other key areas were painted
with white acrylic in the final stages of the painting.

Sirens: The Essentials

These sea fairies are usually depicted as nymphs or mermaids, though it is said that they once looked like bird-women. Their wonderful singing is an irresistible enchantment, drawing men to their deaths as they either jump overboard or wreck their ships on the rocks in an attempt to reach the exquisite music. The shore of the sirens' island is littered with the bleached bones of sailors. Only one man heard their singing and lived, the clever Greek hero Odysseus, who stopped his men's ears with wax and tied himself to the ship's mast so that he could listen without succumbing to the sirens' fatal charms.

BLEACHED BONES

✳ Sirens are surrounded by the bleached bones of their victims; human skulls lie on the bottom of the sea with sea serpents swimming through them, while ribcages are entwined with seaweed. Sirens are seductive but deadly, clasping their victims in a fatal embrace while they pull them beneath the waves to drown.

SHIPWRECKS

✳ Sirens exist in order to call sailors to their deaths, drawing them from their ships, which then founder on the rocks. In a frenzied attempt to reach the enchanting music, the doomed sailors struggle to reach the shore of the sirens' island, ignoring the imploring cries of their drowning shipmates.

THE PERILOUS ISLE

✳ The island of the sirens is a barren rock surrounded by sharp reefs. The turbulent sea that laps its shores is white peaked and cruel. Creatures with stings and pincers roam its shores, waiting for their share of the prey. Try reflecting the threatening nature of the siren with a dark, stormy sky.

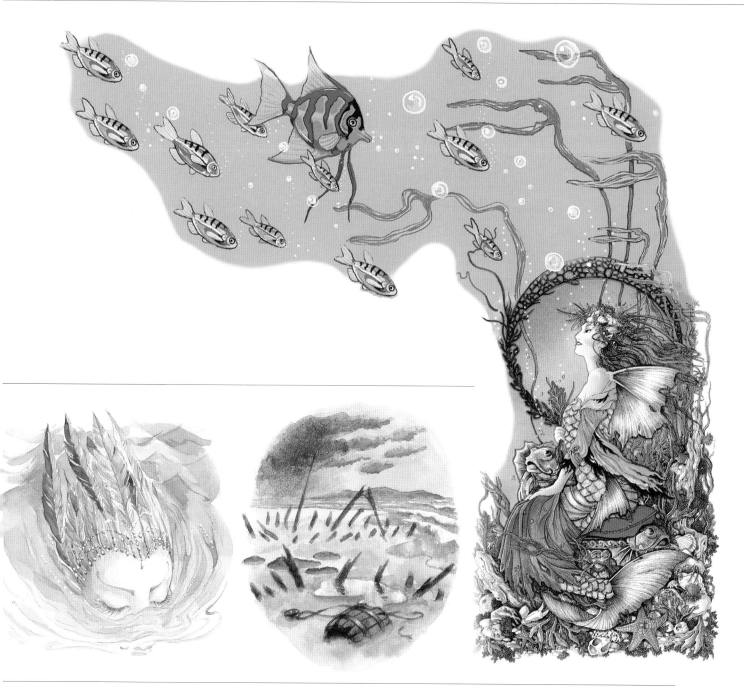

CROWNS OF FEATHERS

✳ Sirens are sea nymphs, who were once part bird and part woman, and they retain the irresistibly sweet singing voices they possessed when they were bird-women. Their origins could be suggested by portraying them in feathered crowns, but alternatively, a siren's long, flowing hair could be twined with pearls and coral, held back with clam-shell combs, or she could wear a crown of spiked shell.

FLOTSAM AND JETSAM

✳ The waters around the sirens' island are littered with the detritus of wrecked ships, with floating oars, barrels, and sea chests. The sirens gleefully climb over them and divide the spoils, taking any trinkets they fancy before abandoning the ruined vessels and their dead crews to the crabs and limpets.

NYMPH OR MERMAID

✳ The siren can either take the form of a mermaid, with a shining fish tail girdled with seaweed, or that of a lovely nymph in human form, clad only in her long hair. She looks out over the wild sea, playing a harp or lyre made from curving shells or mother-of-pearl.

Goblins: The Essentials

Goblins are some of the more unpleasant denizens of the fairy realm; the villains of the fairy world, and companions to the dead, their name means "evil spirit." The best time to see goblins is Halloween, when they emerge from their homes which lie in tree roots, caves, or grubby holes in the ground. Then they will haunt the churchyard with the ghosts, or make mischief around the village trying to tempt people into eating fairy food, which will make them the prisoners of the fairies forever. Goblins are small, swarthy, ugly creatures, who look like squat, crooked humans, and the smile from one is horrible enough to turn milk sour.

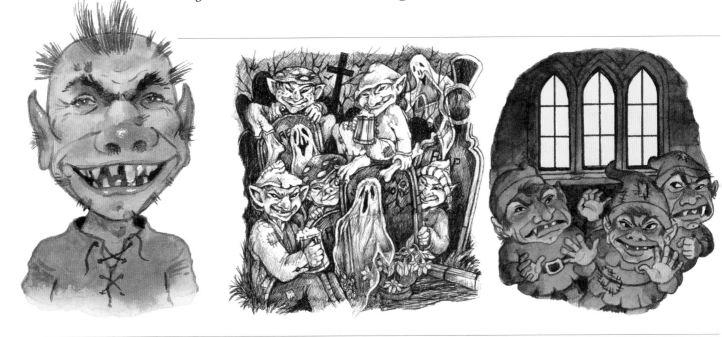

HIDEOUS GRINS

✳ Goblins have horrible grins, even worse than the cathedral gargoyles who might be said to be some of the goblins' better-looking cousins. They have bad teeth like listing granite tombstones, tufts of spiky hair in between bald patches, broad flat noses, piglike eyes, warty skin, and large cauliflower ears.

HALLOWEEN

✳ Lonely ghosts and ghouls are the only creatures that will keep company with goblins. They come out of their graves and lairs on Halloween to hold a ghastly celebration, waiting beneath gallows or behind tombstones, ready to jump out with a friendly grin to play "trick or treat" on unwary humans.

CHURCHYARDS

✳ Churchyards are the favorite gathering places of goblins, and they like them so much that they sometimes live in old graves. The playful creatures use the skulls of the previous tenants as cups, their finger bones as handy forks, and their thighbones as heavy clubs to hunt wandering wolves, bats, owls, and cats.

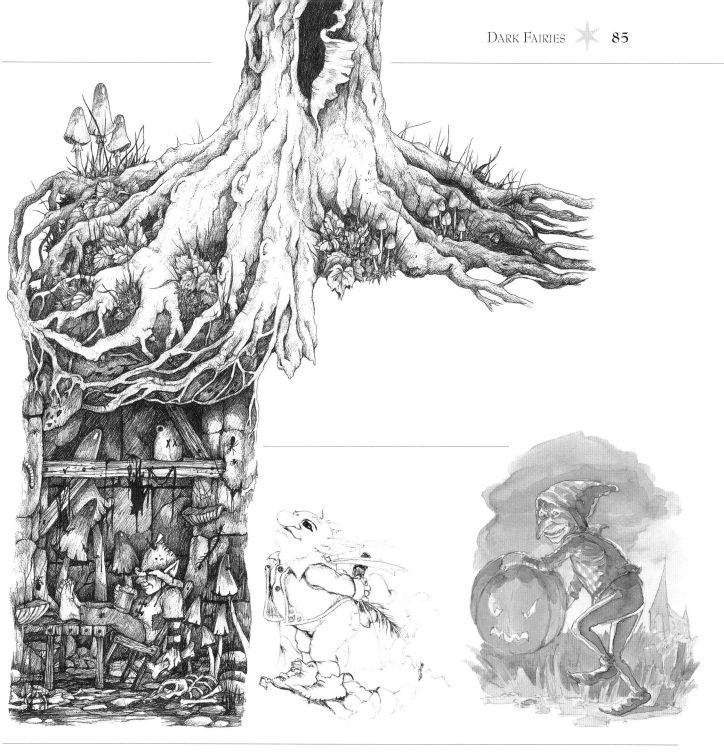

DARK PLACES

✳ Smaller goblins love dark, slimy places and choose to live in dank caves, inside tree roots, and beneath smelly holes in the ground. Their beds are made from spider webs, their tables from toadstools, and their chairs from rat bones. They feast on flies and juicy worms, drinking cider made from rotten apples.

UGLY CREATURES

✳ Goblins are short, varying in size from a few inches to three or four feet tall, and have a squashed, misshapen appearance, bowlegged and with crooked backs. Perhaps their unfortunate appearance is the reason why they are so miserable and keen to cause mischief if they can.

MOTLEY COSTUMES

✳ Goblins wear dark clothes as a rule, with hoods pulled over their heads to hide their ugliness from everyone but each other. Since all their clothes are stolen, they may wear incongruous mixes of tattered old rags, fine velvet and lace, or even shrouds and winding sheets taken from the dead.

Banshees: The Essentials

Banshees adopt families of pure Celtic blood, and their unearthly wails pierce the air when death or disaster is about to befall them. Their keening is said to resemble a combination of a wild goose's screech, a wolf's howl, and the pitiful cry of an abandoned child. If a member of the family goes out to look, the banshee may be seen sitting in the branches of a tall tree, silhouetted against the moon, combing her long black hair. The family member must be careful though, as if one of these hairs falls on him he will be cursed forever more.

THE WELSH BANSHEE

✳ The Cyoerraeth, or Welsh banshee, appears at crossroads on dark nights. She taps on the windows of those about to die, or announces shipwrecks by carrying a ghostly candle along the seashore. She may appear as a withered hag, or in a more frightening form with leathery wings, matted hair, and long, black teeth.

THE WASHER AT THE FORD

✳ The banshee is a female spirit who shrieks or wails to foretell a death. The Scottish banshee is called the Washer at the Ford because she appears beside a stream or lake washing the bloodstained clothes, shroud, or armor of the one about to die. She looks like an old woman, though some say that she has webbed feet and hands.

THE IRISH BANSHEE

✳ The Irish banshee may take on the appearance of a young girl, or perhaps a dead relative. In Donegal, the banshee adopts a green dress and gray cloak, while in County Mayo she dresses in black mourning. Elsewhere she may wear a shroud or a white dress and veil.

MOONLIT NIGHTS

✳ Banshees often appear on moonlit nights to shriek their ominous warnings. They may take up their places in the branches of trees, accompanied by owls, bats, and other night creatures. You can add to the atmosphere of your painting by making the branches stark and bare, and silhouetting the figure against the full moon.

APPEARANCE

✳ The banshee's eyes are always deeply shadowed, hollow, and red from weeping. Her skin is ashen and ghostlike since she never sees the light of day. All banshees have long hair, smooth and fine, or thick and matted, and they sit in their trees and comb it as they sing.

EVIL OMENS

✳ The mysterious banshee is sometimes accompanied by other evil omens such as the *cóiste-bodhar* or "death coach," an immense black coach with a coffin on it, which is pulled by headless horses and driven by a ghost. Occasionally several banshees might wail in chorus at the death of an important person.

Queen of the Night *by Jessica Galbreth*

The Queen of the Night is based on the human form, with the exception of the wings and the traditional pointed ears. She is set against a cosmic background of continuous, gradually shifting rich tones of blue, green, and violet. Salt is used in the background washes to create the effect of swirling starlight.

1 Make initial sketches to establish the layout and position of the figure, then draw it out on watercolor paper using a 2H pencil. Include the dividing lines in the background and all the details, such as the moons, the leaves in the headdress, the facial features, and the armband. Keep on erasing and redrawing the various elements until you are satisfied with the shapes and proportions of the composition and the overall look of the fairy. Take your time as it is easier to make changes at this stage.

2 Lay in the background first, taking care not to paint over the outline of the figure. Using a No. 6 brush, and starting with the left-hand section, quickly lay in a fairly strong wash of medium-toned cobalt blue and ivory black, starting from the outer edge of the wing. Work around the moon initially, then dilute the wash slightly and fill in the shape. Before the wash has dried, sprinkle table salt into it, and then rinse the brush and dribble fairly large droplets of water into the paint and salt mixture. The paint will separate and create a crystalline pattern. When this section is complete, paint the shape between the arms and body in the same way.

COLORS USED

Cadmium Yellow	Cobalt Blue
Cadmium Red	Turquoise
Magenta	Cobalt Green
Mauve	Vandyke Brown
Violet	Ivory Black
Ultramarine Violet	White Gouache
Dioxazine Purple	

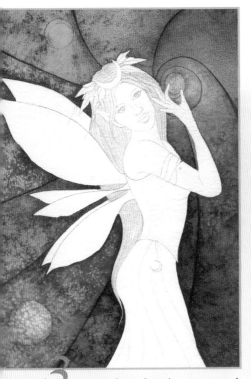

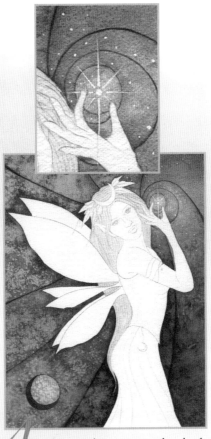

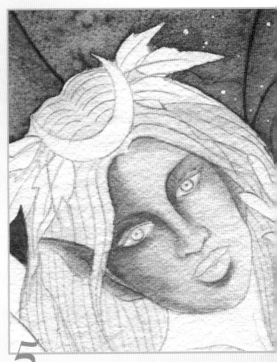

3 Now work on the other sections of the background, keeping the washes close in tone and aiming at gradually evolving shades of violet, blue, and green. On the right, use mixtures of violet, mauve, and magenta, and to the left use mixtures of cobalt blue, turquoise, and cobalt green. Overlap each new section slightly with its neighbor to emphasize the swirling pattern. When you reach the star, dilute the wash to create the impression that the star is giving off its own light.

Lay in a very pale cobalt blue wash over the fairy's hair and around her face and shoulders, then fill in the area of hair that runs down her back with a watery dioxazine purple wash to smooth the transition from figure to background. When dry, scrape away the remaining salt with your fingertips.

4 Paint over the crescents of each of the two moons with a No. 2 brush and darker versions of the original colors, leaving the centers lighter than the sky. Add the star and some stardust with white gouache as follows. Squeeze out a small amount from the tube, dip a No. 00 brush first into water and then into the paint, and make tiny strokes for the rays of the star. Use the small brush again to make minute dots of white gouache for the specks of stardust.

5 For the skin, mix a dilute wash of Vandyke brown and cadmium yellow with a touch of cadmium red and apply it as a flat wash to the face and ears with a No. 6 brush. Add shadows to model the face while the first wash is still wet. To make a link with the background colors, use a mixture of cobalt blue and ultramarine violet, picking up just a little color with the tip of the brush, which needs to be kept fairly dry.

Starting at the edge of the face and working gradually inward, lightly add shadows on the cheekbones, near the hairline, and around the eyes. Let the color become paler toward the center of the face.

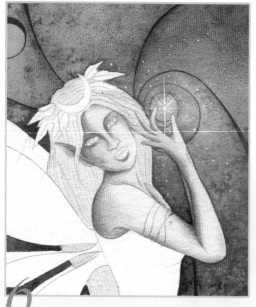

6 Lay a flat wash of the skin color over the neck, shoulder, and arm. Bearing in mind the direction of the light source, add shadows under the chin, down the back of the neck and shoulder, and along the outer edges of the arm. Take a few steps back and squint at the painting. If a few other areas could benefit from shadows, or deeper shadows, add them in.

7 Using a No. 00 brush and concentrated ivory black, very lightly outline the fairy's body, limbs, and facial features, working over all the pencil lines including those for the armband. To make the eyes stand out, use a dark black outline and then draw in long, thick lashes. Fill in the irises with a very pale cobalt green, keeping the effect light.

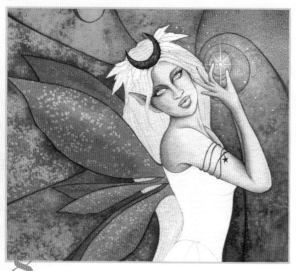

8 Salt is used to create the star-speckled effect on the wings. Mix two washes, one of magenta and one of cobalt green. Using a No. 6 brush, apply the green wash across the upper part of each wing and the magenta in the lower part, letting the two colors blend together. While the paint is still wet, sprinkle a little salt onto each wing. For the tops of the partially obscured wings, use the same technique but with darker washes to create a sense of depth. Outline the moon crown in deep magenta using a No. 00 brush, then dilute the color slightly, fill in the shape, and sprinkle on a little salt.

9 To complete the hair, mix a darker cobalt blue wash and dip just the tip of the No. 6 brush into it. Paint the individual strands with quick, sweeping strokes. Skip some areas to leave highlights, and darken others by adding more strands. With a dark cobalt blue—green mix and a No. 2 brush, draw down the center and soften the line a little. Refill with a lighter wash of the same green and paint over the entire leaf. Complete all the leaves in the same way, then add ivory black to the green mix and outline the leaves with a No. 00 brush, adding a few fine veins.

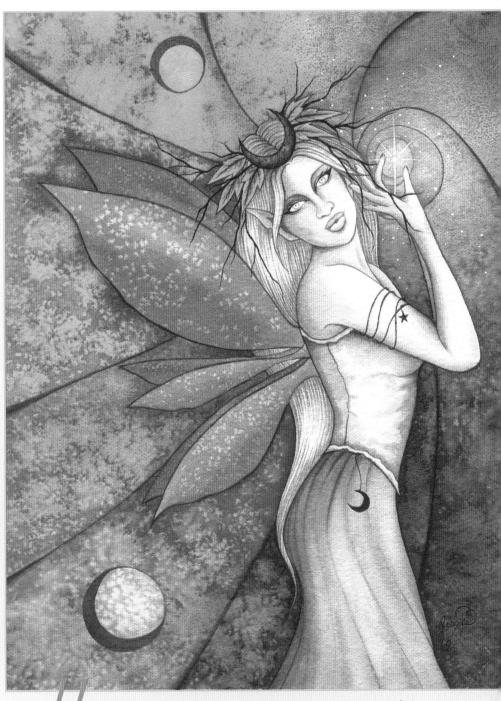

10 *Light tones of the background colors are used for the dress. Begin by painting a very watery light cobalt blue wash all over the dress with a No. 6 brush. When this is still damp but not too wet, add other colors wet into wet (see page 18), alternating bands of magenta, cobalt blue, dioxazine purple, and cobalt green.*

Along the folds of the skirt and on the bodice, let each color blend into the next. Add more color for shadow areas in the folds of the skirt and around the arms, but leave the original pale blue wash showing for light areas. When you have built up the colors sufficiently, go over the whole area with a wash of clean water, which smoothes the colors into each other and creates a soft, blended effect.

11 *Add final details to the dress wet on dry (see page 18). Using the smallest brush and ivory black paint, outline the dress and the side-seam on the bodice, which has the effect of separating the fairy from the background and bringing her forward in space. Finally, outline the hanging moon ornament on the dress and fill it in with the black paint.*

FAIRY HELPERS

Some fairies take a great interest in humans and will help their favorite people. They admire simple folk who are generous and hard working, and hate those who are lazy, quarrelsome, and greedy.

THE GUARDIAN ✳ LINDA VAROS (below)
The Guardian Fairy appeared to the artist in a dream, and she felt compelled to paint her as soon as possible before the dream-image faded. She quickly sketched her daughter in the appropriate pose, transferred the drawing to watercolor paper, and began to paint, working from background to foreground. The clothing and wings were left until last, so that the overall coloration could dictate the final shades of these. The pale and delicate colors remind us of the fragility of the eggs themselves, and the irregular frame of apple blossoms that encircles the nest stresses the theme of the protection of precious objects.

SPOTTED RED ✳ KATE DOLAMORE (above)
The impact of this dramatic painting stems from the bold use of red and black in strongly contrasting tones. The skin tones and background were painted wet into wet, and the red spots on the wings and skin (inspired by real creatures with similar marks—such as leopard frogs) were applied when the rest was dry. A black marker was used to create the border, and highlights were added to the wings and eyes with white gouache.

CONSTELLATION ✳ MYREA PETTIT (above)
This painting, commissioned by a stationery company
to illustrate party invitations, shows a flying procession
of fairies led by Aurora, goddess of the dawn. The artist
worked from photographs of playing children to
maintain a naturalistic and unaffected mood, and the
wings were based on various species of butterfly, with
great care taken to achieve realistic accuracy.

THE LEPRECHAUN ✳ JAMES BROWNE (left)
This leprechaun, created for a book illustration, is
shown surrounded by ragwort flowers with his legendary
pot of gold at the end of the rainbow. It is well known
that leprechauns possess vast wealth, but you would
need to be very sharp in order to win any from them.
There is a story that a leprechaun showed a farmer the
one and only ragwort in the field under which gold was
buried. Thinking himself very clever, the man marked it
with a red ribbon while he went to get a spade. When he
came back there was a red ribbon on every ragwort.

THE BEE CATCHER ✴ JAMES BROWNE (right)

This comical little fairy is trying to capture a bee with his tiny net. Like fairies, bees are magical creatures believed to be messengers from the Otherworld, privy to all the old wisdom, hence the Scottish proverb "Ask the wild bee for what the Druids knew." This image was first drawn in sepia ink, and a series of watercolor washes were applied within the lines. White gesso was added for the highlights.

THE OLD LIBRARIAN ✴ MYREA PETTIT (below)

This venerable fairy librarian, drawn with a waterproof ink pen and watercolor pencils, was envisaged as being over a thousand years old, with fragile wings like tattered, ancient paper. The central image is framed by a drawn-back curtain, suggesting that we are being allowed a brief, stolen glimpse into a private world. While the librarian himself is lit by a bright candle, everything else is thrown into shadow, and the corners of the library are dark and mysterious. Notice the creature peeking out from behind the books on the top shelf. And are those eyes in the woodwork?

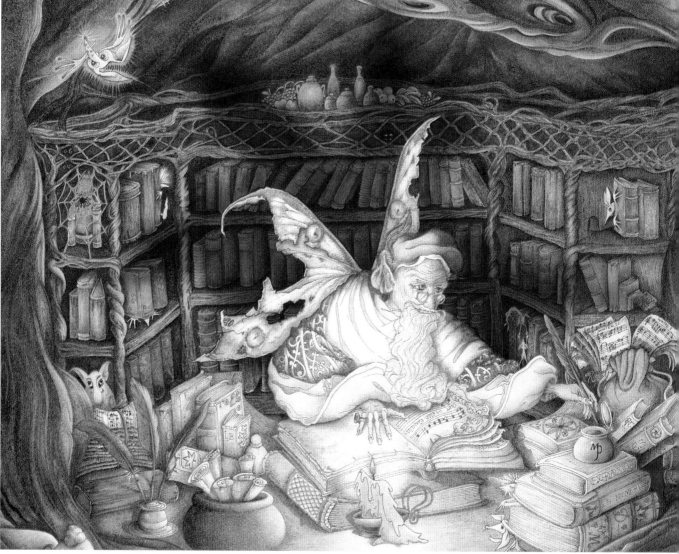

PIXIE ON A SHELL ✳ **MYREA PETTIT** (left)
A shell collected on the artist's travels was the
starting point for this charming painting of a sleeping
pixie. The figure itself was drawn from one of her own
photographs of children—she prefers to take these
when the models are not posing, so that they appear
natural and unselfconscious. Entwined periwinkle
flowers and a few toadstools were added to
complete the composition. A pencil drawing
was made on the working surface, and the
painting was built up with waterproof
ink and watercolor pencils, with an
eraser used to blend colors
and remove areas
for highlights.

GREEN SPRITE ✳ **AMY BROWN** (right)
The pose for the fairy was taken from a
reference book of life studies, and the
painting was begun with a background wash
of light green. Darker greens were then
added, and texture was produced by
dropping salt into the wet paint. The salt
sucked up the darker pigment, allowing the
lighter green to show through. While the
paint was still wet, the areas around the
wings were blotted to achieve a glowing
effect. The sprite herself was added on top
of the background wash, with the shadows
on the skin painted first, followed by two
or three dilute washes.

THISTLE FAIRIES ✶ LINDA VAROS
(right) Two elegant, white-gowned
fairies strike a dignified, reflective pose
beside a thistle plant, which sets the
scale and tells us how small they are.
The vibrant effect stems from the
strong contrast between the bright
green and red of the thistle and the
background color, a loose wash of
blue and deep purple, which is carried
through into the wings and gown of the
background fairy. The same color is
repeated in all the shadows, giving the
impression that the fairies have their
own inner light. This is emphasized
by the brilliant white dress of the
foreground fairy, which has been left
deliberately under-painted so that the
white paper shines through.

THE SMALL SEED ✶ KRISTI BRIDGEMAN (below)
Produced as part of an environmental awareness exhibition, this
painting aims to encourage tomorrow's environmentalists by
planting a small seed in the imagination. It was designed to appeal
specifically to children, with strong lines, cartoon characters, and
bright colors. Busy, happy fairies, watched by bees and ladybugs,
labor on this year's harvest, collecting seeds and berries. The
drawing was made in sepia ink with washes applied on top, both wet
into wet and wet on dry. The fine veins in the wings were scratched
out with a pin while the paint was still wet.

THE FAIRY GATHERING ✶ JAMES BROWNE (opposite)
This painting, with a fairy family playing among plants
found in many ordinary suburban gardens, gives the
impression that there really are "fairies at the bottom of
the garden." Who knows what you might find if you
were to look under the rose bushes in your yard right
now? The real delight stems from the many painstaking
details such as the little fellow with a belled collar and
hoop, and the flower-hatted fairy child reaching for an
insect. You would probably discover something new
every time you returned to the picture.

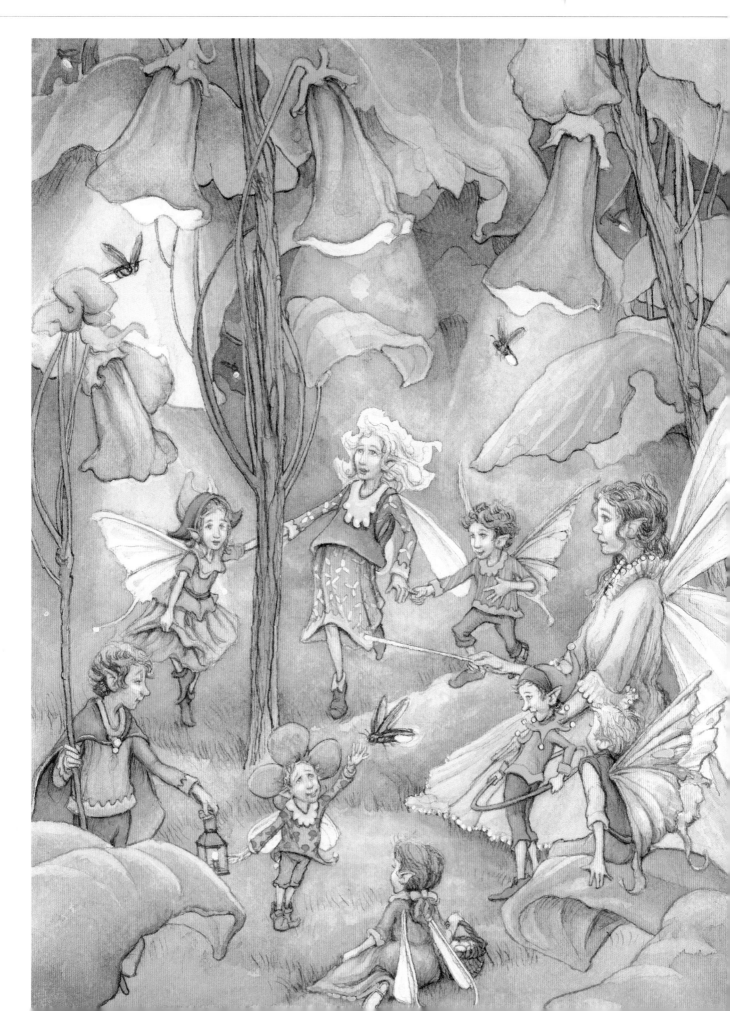

Pixies: The Essentials

The moorland of south-west England is alive with these playful fairies, who delight in playing practical jokes on the unwary. One of their tricks is to "pixie-lead" travelers or, in other words, to lead them astray from their path across the heath. Another favorite prank is stealing horses and ponies, riding them wildly through the night before returning them in the morning tired out (with knotted manes and tails), to the farmer's puzzlement. Their humor is good natured, however, and, if they choose, pixies can be as helpful as brownies. One Devonshire farmer found his barns full of threshed grain, a gift from the pixies.

LITTLE MEN

✶ Dartmoor pixies are the size of two-year-old children, and have pale or green skin. They wear ragged costumes of green or brown, trimmed with bells. The Cornish "piskies" of Bodmin Moor are very different in appearance: they are dapper little men with bright eyes, white waistcoats, green stockings, and highly polished shoes.

GREEN OR PALE SKIN

✶ Pixies are moorland spirits, living in Dartmoor and Bodmin Moor in south-west England. This is a region rich in legends and folklore, sparsely populated, but with many prehistoric remains—burial mounds and stone circles. It is an area full of beauty and atmosphere, with hills, green woods, and valleys as well as bleak moorland with high granite hills carved into weird shapes by the wind.

TRICKSTERS

✶ Pixies are famous tricksters. They may substitute pixie children, called "killicrops," for human babies, sneaking into a cottage while the farmer's wife is busy in the yard, and then laughing at her shrieks when she discovers the fairy changeling. They may return the human child when they have had their fun.

FLORA AND FAUNA

✳ Set the scene with depictions of the bleak and mysterious moors, which are covered in heather, foxgloves, bluebells, whortleberries, violets, sundew, fern, and bracken. These attract numerous butterflies, including painted ladies, peacocks, and fritillaries. The fauna include roe deer, otters, bats, buzzards, herons, curlews, snipes, pheasants, skylarks, and lapwings.

PONIES

✳ Pixies have a great interest in horses and ponies. They love to capture and ride the famous wild Dartmoor ponies, which are rough-coated sturdy animals, twelve hands high and usually dark brown or black in color. Pixies ride them around in circles to create a "gallitrap" or fairy ring.

FIND YOUR PIXIE

✳ The Cornish believe that pixies live in the old burial mounds that are scattered across the county, and are sometimes called "Piskies' Halls." Dartmoor pixies live in caves or burial mounds, and will dance in the shadows of the old standing stones or caper at the stream's edge on moonlit nights.

Elves: The Essentials

Elves are larger than most fairies, being of human size or even slightly taller. They live in large communities in specific woodland groves, or underground inside the fairy hills. Elves are ruled by a king and queen, and are sometimes called "trooping fairies" because they ride out in magnificent processions behind their rulers, mounted on prancing ponies whose eyes flash with fire and whose hooves are shod with gold. The males are stately and handsome, while female elves have an unearthly beauty, with long, pale hair that sweeps the ground, and dew-sprinkled gowns that sparkle as though set with diamonds.

TALL AND SLENDER

✳ Elves are often taller than humans, with whom they sometimes mingle undetected. However, they are more willowy and finely made than people, with delicate features, arched eyebrows, and pointed ears. The women are very beautiful, with long hair that sweeps the ground as they walk. The men are gallant, quick, and nimble.

ELFHAME

✳ Elves live in secluded woodland groves, where they have treehouses or homes inside hollow oaks. Some live in fine palaces inside fairy mounds. They spend their time hunting, hawking, and feasting, or playing chess, especially the old Irish version of the game, which is called "fidchell" or "wooden wisdom."

DRESS IN GREEN

✳ Elves are dignified fairies, and are garbed in stately style. The women wear shimmering white, full-length gowns with wide sleeves, and the males dress in green tunics and leggings to enable them to hide in the forest. They carry bows and arrows tipped with flint to defend their lands against human invasion.

THE FAIRY RADE

✳ At certain times of the year, such as May Day and Halloween, elves will ride out in a procession called the "Fairy Rade" (ride), mounted on white horses hung with silver bells, and with banners and flags flying. These are fairy horses, as swift as the wind, with fiery manes, golden hooves, and flashing eyes.

KING AND QUEEN

✳ The procession is always led by the elven king and queen. The queen is more beautiful than any earthly woman, with long golden hair, and clad in silver gossamer sparkling all over with dewdrops. The king is handsome and noble, and carries a crystal-topped staff.

Gnomes: The Essentials

Gnomes are earth fairies, their name meaning "earth dweller," and it is said that they can move through their element as easily as a fish moves through water. They protect and guard all the things of the earth, from the treasured minerals and metals within it and its rocks and stones, to the plants that grow on it, though it is really the soil that gnomes are concerned with. It is for this reason that many people have little protective statues of gnomes in their gardens, showing them as jolly-faced little men with red caps, tunics, belts, and boots.

FAIRY MINERS

✳ Gnomes own everything that is found within the earth: its seams of precious metals, coal, gemstones, crystal geodes, jewels, lost treasure, and even the seeds in the ground. Human miners once prayed to them before starting work, and they are miniature miners themselves, often pictured with picks and shovels.

CAPS AND BELTS

✳ Garden gnomes are usually clothed in tunics of green or red, but in reality gnomes choose earthy colors of brown, green, ocher, and rust, dyed with the lichen and mosses of their kingdom. They also use anything they find within the earth, such as dried plant material, rabbit fur, and metal. They often wear red pointed caps.

CHEERY CHAPS

✳ They have jolly, craggy faces, with large noses and pointed ears. Every gnome has a beard, which may be short and bushy, pointed and well groomed, or long and smooth, extending down to his feet. Sometimes gnomes plait and braid their beards, which is the only vanity they allow themselves.

MAGICAL SMITHS

✳ Like the dwarf, with whom he is sometimes confused, a gnome likes to work with metal, and may be depicted as a smith at the forge, with hammer and anvil. He is an expert on the properties of metals and gems because he is intimately connected with everything subterranean.

JOLLY FACED

✳ Gnomes are little fellows, only six to eight inches in height, which enables them to pass easily through the earth. They are crumpled and elderly in appearance, although they are strong and muscular from the hard, physical work they perform, with gnarled finger joints and large hands, feet, and elbow joints.

EARTH DWELLERS

✳ Since gnomes are earth spirits, they are always found in close contact with the soil, and most often inside the ground, building houses in the roots of trees, caves, or at the bottom of human gardens, using whatever is left lying around. If they are shown respect, they will protect the plot.

Leprechauns: The Essentials

Leprechauns are cobblers who make the shoes for all the fairy gentry. They are usually seen with a last and hammer but, for some reason, only one shoe in the making. The Irish will tell you that the leprechaun hides his pot of gold at the end of the rainbow, and if you can reach the end of the rainbow, he will be forced to hand it over. Leprechauns are small, wrinkled, and usually dressed in a homely fashion. Don't be surprised if you catch him enjoying a pipe of tobacco and a glass of good Irish whiskey.

COBBLERS

✳ Leprechauns are solitary creatures rarely seen in the company of other fairies. They are famous for their skills as cobblers, and may be discovered at their work under the hedgerows, beside stiles, or in the cellars of deserted houses. They are sometimes tinkers as well, traveling the byways of Ireland leading their pretty little gypsy caravans and horses.

OLD FELLOWS

✳ Leprechauns have an aged appearance with withered, wrinkled skin. They have wide mouths, red noses, and mischievous bright eyes. They love fun and gather together on May Day and at Halloween for Leprechaun festivities. All leprechauns are musical and can play the fiddle, Irish harp, and pennywhistle.

CASTLES

✳ Rather than building their own homes, leprechauns prefer to move into houses and castles abandoned by humans. Very few leprechauns would choose to live with humans, the exception being the Cluricanes, Munster leprechauns who live in wine cellars enjoying the barrels of beer, casks of wine, and pipes of port.

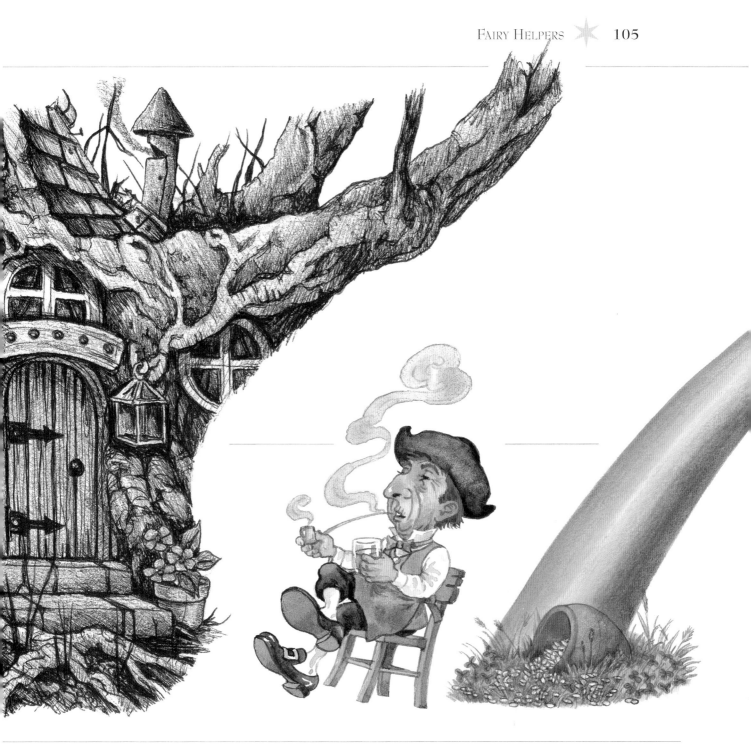

TREEHOUSES

✳ Leprechauns may make their homes in the roots of trees, preferring the hawthorn. In a pinch, they will take over abandoned animal burrows or even beehives. There is a strong rapport between leprechauns and animals, especially the red-breasted robin, though they may also ride dogs, sheep, and owls.

LEPRECHAUN FASHION

✳ Varying in size from a few inches to nearly as tall as humans, leprechauns usually wear shabby green jerkins, waistcoats and leather aprons, pocket watches, and purses. While some wear red caps or pointed hats, others prefer old fashioned three-cornered hats. Their fine leather shoes have silver buckles.

RAINBOW'S END

✳ Leprechauns love treasure, especially gold, and they may go out on dark nights armed with picks and shovels to search for buried riches. Every leprechaun owns at least one pot of gold, which he hides at the end of the rainbow. Vary rare lunar rainbows hide the most valuable hoards.

Winter Outfit *by Myrea Pettit*

The wings of these fairies are based on those of the male and female silkworm moth, and this, together with the accurate and careful observations of the dandelions and other plants, gives a nice blend of fantasy and naturalism. The details on the wings and faces are built up with watercolor pencils over watercolor washes.

1 The artist likes to sketch out her compositions on bleedproof Letraset marker paper and then ink them in before transferring the drawing to the working surface. However, this is not essential—you can use good-quality drawing paper instead. Sketch the composition in pencil, keeping the lines light. Then draw over the pencil lines with a drawing pen and waterproof black ink. Only ink over the focal points such as the outlines of the figures and the dandelion seed heads; the background, facial features, and wings can be left in pencil.

2 Continue to ink in the focal points in the foreground, concentrating on the pencil lines as you draw so that the pen does not wander. When you have completed the ink drawing, erase the pencil marks around the inked lines but leave the rest of the pencil drawing as a guide for painting.

COLORS USED

Lemon Yellow Yellow Ocher
Vermilion Raw Umber
Cadmium Red Ivory Black
Alizarin Crimson White Gouache
Hooker's Green

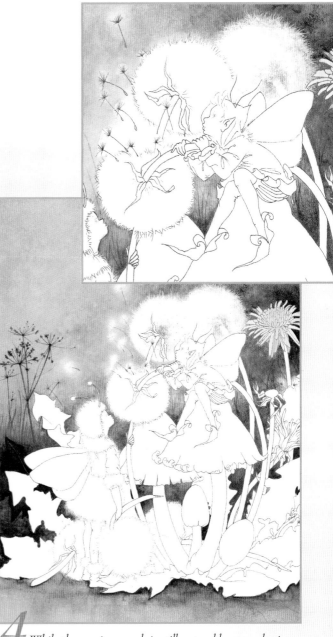

3 Transfer the inked image onto the working surface, either by tracing, photocopying, or laser printing. Apply a variegated background wash (see page 17), using a No. 8 brush and watery washes of lemon yellow with touches of Hooker's green at the top. Darken the green mix with ivory black for the areas behind the figures, and use alizarin crimson and yellow ocher in the lower part. Let the colors blend into each other, and flick on some drops of water in the foreground to add texture.

4 While the previous wash is still wet, add more color in the background, working wet into wet (see page 18).

Let this area dry and then paint the dandelions, starting with the farthest and working forward. Fill the seed head with a very pale wash of yellow ocher, then mix a slightly stronger wash of alizarin crimson, yellow ocher, and ivory black and add the shadow area around the stalk. When this is dry, add tiny dots of cadmium red and ivory black for the seeds and put in hairlike strokes with white gouache and a No. 00 brush.

Using a No. 2 brush, paint the grasses in the distance with Hooker's green and a dull cadmium red. Then put in the cow-parsley with the same colors plus ivory black.

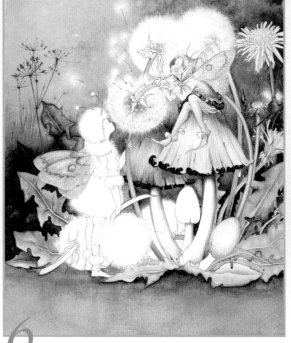

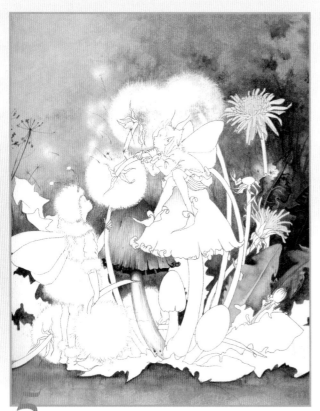

5 Add in leaves and stalks on the right, using Hooker's green and yellow ocher for the lighter leaves. Use lemon yellow on the dandelion flowers, and apply a wash of raw umber over the tops of the mushrooms. When dry, wash over with vermilion. Use diluted ivory black with touches of cadmium red and Hooker's green in the lower part and let the two blend together. Put in some gray shading down the stalk.

6 Draw in the wing veins with pencil, then fill carefully with dilute washes of yellow ocher in the upper sections and cadmium red in the lower ones. When dry, use watercolor pencils to work up the color on the wings, and finish by painting the fine, trailing hairs around their edges with a No. 00 brush and white gouache.

Lay washes of yellow ocher and Hooker's green on the clothes of the right-hand fairy, darkening with ivory black for the shadows in the folds. Apply a thin wash of raw umber on the dandelion stalks, and then use Hooker's green and vermilion watercolor pencils to build up the colors.

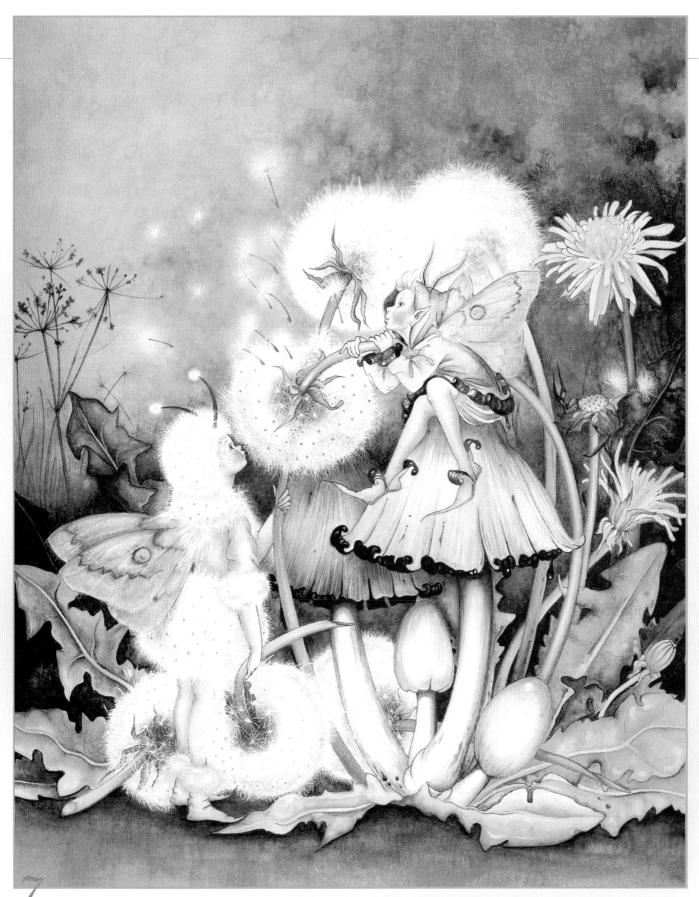

7 Complete the remaining seed heads using diluted ivory black and a mixture of diluted cadmium red and alizarin crimson, adding in detail as you work. Paint the left-hand fairy's bodice with a pale wash of yellow ocher and vermilion, darkening it slightly to add shadow to the outer edges of her body and arm. Put in the eyes, mouths, and cheeks using watercolor pencils. With a cadmium red pencil and fine but blunt strokes, put in the right-hand fairy's antennae. Notice the ink dripping off the edge of the ink cap mushroom.

FAIRY REALM

The fairy realm overlaps our own, concealed from human sight. At certain magical times and seasons it may become visible for a while and, if you are lucky, you may then glimpse the otherworld.

BUTTERCUP AND ACORN FAIRY ✳

MYREA PETTIT (above) The composition is based on a triangle, which is emphasized by retaining the white of the background. The little fairy in an acorn hat, at the apex of the main triangle, perches on top of an ink cap mushroom (another triangle shape), smelling a flower held up to him by the buttercup fairy herself. The image was first drawn with a black waterproof pen, and then built up with watercolor pencils. An eraser was used to blend the colors and create subtle highlights.

FAIRY QUEEN'S PASSAGE ✳

MEREDITH DILLMAN (left)
An elegant fairy steps toward us out of a frame made by trees in a snowy landscape. She is thrust forward in space by the contrast between the rich reds of her dress and the cool blues of the landscape—the cool colors recede, while the warm ones advance. The composition was sketched out on drawing paper, transferred to watercolor paper, then drawn in pen and ink and painted with watercolor washes. Salt was scattered into wet paint to achieve the spotting effect in the sky, and tiny drops of white gouache were spattered over the whole painting for snow.

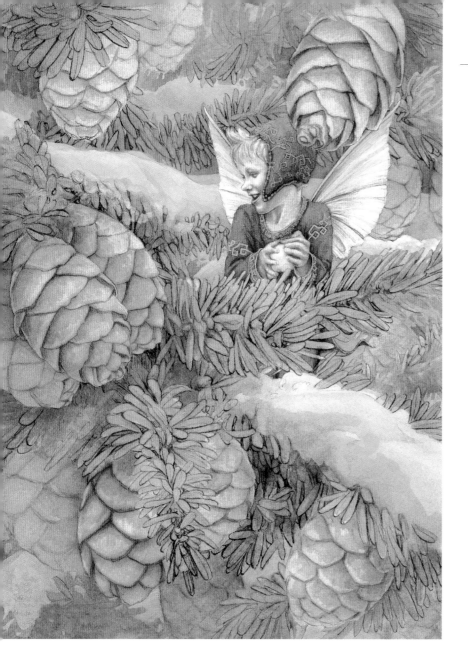

EGAN ✳ JAMES BROWNE (left)
A small, mischievous fairy, perched in a snow-laden fir tree, prepares to throw a snowball. The artist conceived the idea for this painting after being battered with numerous tiny natural snowballs when walking beneath a snowy tree, causing him to imagine that there might be a little imp throwing them. The color scheme is based on a muted version of the red/green complementary contrast, with the touches of blue on the fairy's costume echoed in his wings and in the snow. The pine cones and needles were outlined in ink to give them additional definition.

ROSEBAY WILLOW HERB FAIRY ✳ MYREA PETTIT (right)
The angle of the flower stem and the stress on the dainty fairy's limbs give a strong sense of thrusting, forward movement. The composition was first sketched in pencil and then inked in when the artist was satisfied with the arrangement of the various elements. The image was built up with watercolor pencils, kept very sharp with an electric sharpener. An eraser was used to blend colors and add highlights, with some of the whites achieved by using an eraser.

A TOUCH OF FROST ✳ LINDA RAVENSCROFT (right)
A few autumnal leaves cling to the branches of a tree in which a fairy perches. Her skirt and wings are rimed with ice, showing that winter is on its way. She is a frost fairy, a kind of female Jack Frost who paints delicate icy patterns on window panes, and who nips children's noses and toes in her cold fingers. She was drawn in sepia ink and completed with layers of watercolor washes. Notice that the contrast of her blue dress with the red leaves gives a wintry effect to the image. White gouache was used to create the icy areas.

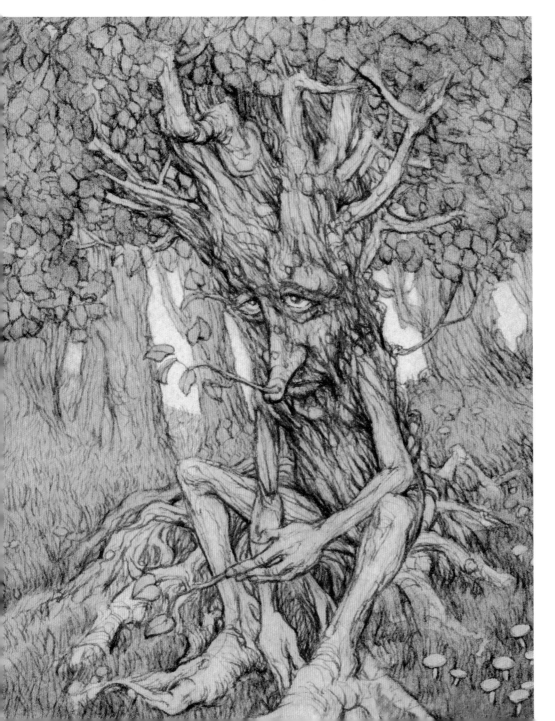

THE ENT ✳ JAMES BROWNE (left) Inspired by the creatures created by J.R.R. Tolkien in his epic trilogy *The Lord of the Rings*, the artist has depicted a melancholy Ent who calls for our sympathy, though the twig growing out of his nose adds a touch of humor. Ents themselves are entirely a product of modern fiction, but they also reflect many older legends of tree spirits found in forest glades, inhabiting certain magical trees such as the oak, elm, hawthorn, and willow. Sepia ink was used for the initial drawing, and the work was completed in watercolor applied wet on dry.

MEGALITHIC STONES ✳
STEPHANIE PUI-MUN LAW (left)
The gaps between the old stones of
megalithic circles and dolmens are reputed
to be entrances to fairyland. Pass through,
and you will find yourself in another world.
In this picture, a red-haired girl has bravely
entered a stone circle, and stands entranced
by the tiny fairies that flit around its
central column. The muted colors of the
artist's restricted palette of purple and
yellow add to the sense of mystery, and the
foreground stones are silhouetted by the
light that emanates from the lotus flower
in the center of the circle.

THE MYSTIC GARDEN ✳ LINDA RAVENSCROFT (right)
This is a highly decorative piece, with its curving, organic shapes and floral
ornamentation owing a debt to the Art Nouveau movement. By using low-key
colors and restricting the palette to autumnal tones, the artist has prevented the
image from becoming overly busy and complex. But it is full of interest: look
carefully at what seems at first glance to be a bird of paradise in the foreground
—it has butterfly wings, so must in fact be a fairy creature. Details like this can
add a sense of the otherworldly to your paintings.

THE MOON POOL ✳ AMY BROWN (right)
The moon, which once seemed more alien and unknowable than it does today, was often seen as a fairyland or a realm of spirits. The artist has created a wonderfully evocative image of magic and moonlight, using an almost monochromatic color scheme of grays, blues, and whites that suggests the silvery light. The tones have been very carefully controlled, especially on the wings, giving the impression that they are tipped with moonlight. White gouache was used in the foreground to highlight the moon's reflection, and touches of texture were added to the leaves and twigs with watercolor pencils.

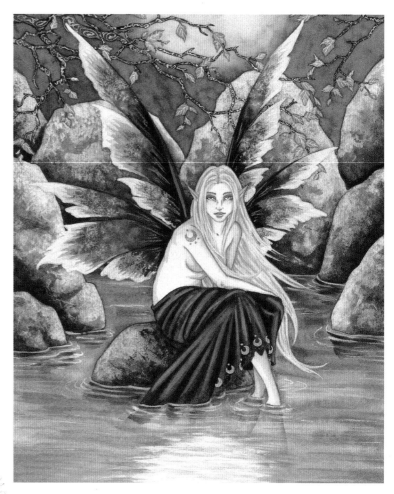

FROGWINGS ✳ STEPHANIE PUI-MUN LAW (opposite)
This eye-catching composition—based on a series of echoing S-shaped curves—is very obviously a depiction of the Otherworld. A mysterious tree, bearing strange fruit or eggs, stretches into the sky, and curious winged frogs flutter around the fairy queen. The painting was built up gradually, with layers of light washes applied wet on dry, with the white of the paper allowed to show through in the paler areas.

TREE NYMPH ✳ VIRGINIA LEE (left)
In this pencil sketch, the artist shows a gentle dryad with hair formed from spreading branches, nurturing the birds that nest in it. The composition has been carefully thought out, with the shape of the twigs repeated in the rough grass that spills over the edge of the hillock on which the fairy sits. Every blade of grass has been lovingly rendered, using a range of different grades of pencil to achieve a full tonal range from white to near-black. An eraser can be used to clean up light areas and add or restore highlights.

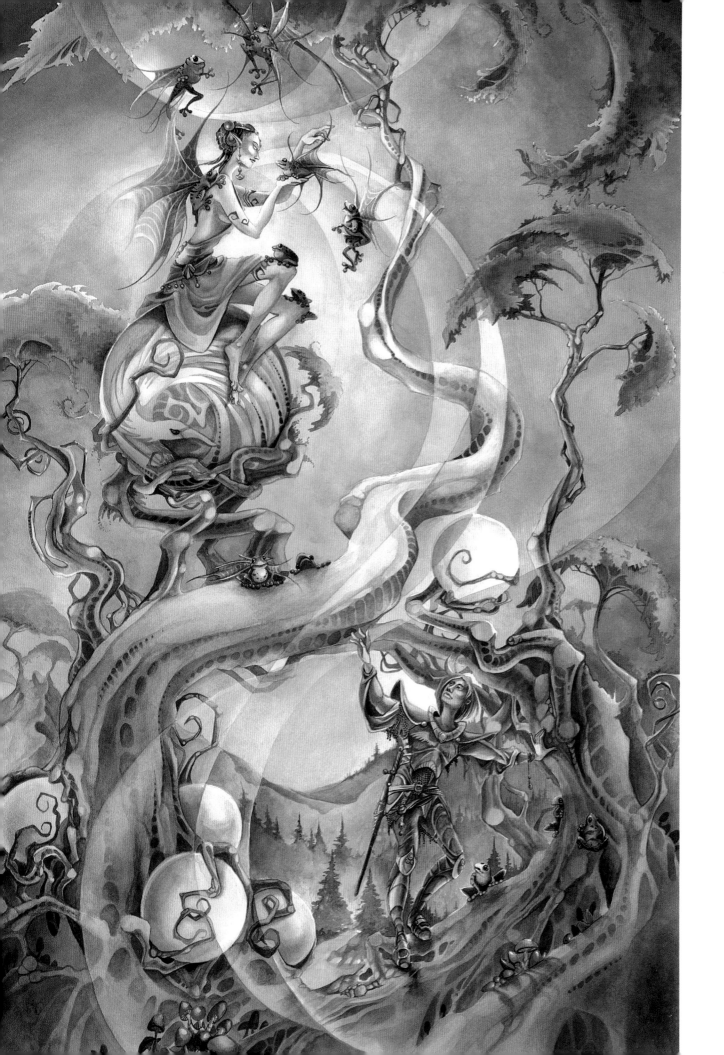

Magical Trees: The Essentials

Perhaps the vast majority of fairies live in forests, making their homes in hollow trees or deep within their roots. They favor certain varieties with magical reputations, such as oaks, elms, hawthorns, willows, and elders. Some fairies embody the spirits of the trees they inhabit, and when we set up our Christmas trees and deck them with lights, we are following a very ancient tradition of honoring such beings. Mortals are welcome in the fairy forest, as long as they respect its laws, but if they should harm its plants or creatures the fairies will take their revenge.

MAGICAL TREES

✷ Fairies may make their homes in trees, but these will be magical ones, not ordinary trees. They may develop a living consciousness from contact with the fairy magic, and if you look carefully you might discern faces in their knotty trunks, and fingers in their spreading twigs. Some even say these trees can move.

THE CHRISTMAS TREE

✷ In ancient times the evergreen tree was a symbol of fertility and the continuation of life during winter, when all other vegetation had died. It was decorated with bright round baubles and lights to encourage the return of the sun. We continue this custom every year when we decorate our evergreen Christmas trees.

FAIRY LIGHTS

✷ You may be sure that fairies live wherever the oak, ash, and hawthorn stand together. Fairies make their homes in the roots of a tree, or inside its hollow trunk. On the nights of the full moon, May Day, or Halloween, the trees twinkle with lights from lanterns strung through their branches.

FAIRY FAVORITES

✷ When it comes to choosing a tree to inhabit, fairies have certain favorites—those powerful trees of ancient forest lore that have magical properties of their own, and which were used in the old enchantments of the Druids. These are the hawthorn, hazel, willow, elder, holly, birch, oak, ash, elm, and rowan.

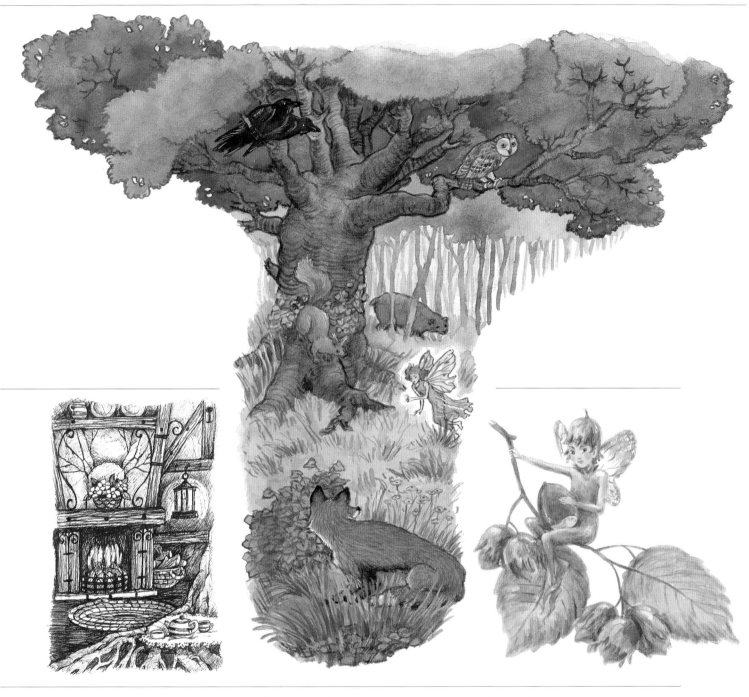

INTERIORS

✳ Fairy homes are cozy, and you can let your imagination run wild to create the interior. There might be lanterns made from seed cases, rush lights, a crib fashioned from half a walnut shell, carved wooden tables, twig chairs, acorn cups, leafy drapes, feathery beds, and rose-petal quilts.

SHELTERED GROVES

✳ Fairy trees stand in secluded places, on unapproachable high hills, or in groves hidden deep within the heart of the forest. Fairies live in harmony with other woodland creatures. You might like to paint them in the company of foxes, badgers, stags, wolves, bears, squirrels, owls, woodpeckers, and robins.

FOREST FASHION

✳ A wide variety of fairies live in trees, including Dryads, the Moss Maidens who spin the green moss for their forest, ethereal White Ladies, Elves, Pixies, Leprechauns, and grumpy little Oak Men. Most of these fairies dress in the greens and browns of the forest to camouflage themselves from human eyes.

Toadstools: The Essentials

Many Victorian and Edwardian illustrations show fairies perched on top of toadstools, usually the red and white spotted fly agaric, or living in little houses inside the fungi. The red caps of the fairies may be made from the mushroom, too. Fungi have always had a magical reputation because of the way they seem to grow and disappear again almost overnight. One kind, the fairy ring mushroom, leaves a ring of toadstools in the grass, and this is where fairies are thought to dance. Some of these rings are up to six hundred years old.

FLY AGARIC MUSHROOMS

✳ Their rapid growth and strange shapes have always given a mysterious reputation to toadstools and mushrooms. The fly agaric mushroom, which has a red cap and white spots, is the one most closely associated with fairies, though there are many other interestingly shaped fungi you might use, such as the giant round puffball, or the shaggy ink cap.

FAIRY RINGS

✳ Occasionally you might find a ring of fairy ring mushrooms on your lawn, an almost perfect circle of little toadstools, mixed with buttercups and daisies in the spring. Inside the ring the grass is always greener; this is because fairies are present there, though they may be invisible to the human eye.

MUSHROOM HATS

✳ Because they are associated with magic, fairies often wear caps of mushrooms, especially red ones. These help the fairies to appear and disappear at will. Fairy milliners supply hats fashioned from fly agaric, liberty caps, milk caps, bonnet mycena, and wax caps. Try working from photographs and sketches of suitably shaped varieties of fungi.

MUSHROOM HOUSES

✶ Some tiny fairies live in houses made from mushrooms, complete with windows, smoking chimneys, and little ladders leading to the doors. Tiny gardens are protected by wicker fences. Whole communities of mushroom houses may spring up in protected places where they are unlikely to be trampled by clumsy human feet.

DANCING FAIRIES

✶ When the moon shines brightly, fairies dance in meadows or on the village green, creating bright green rings on the grass. They are accompanied by fiddlers and musicians, who create music so cheery that it is impossible to keep still when you hear it. But beware—if you enter the fairy ring you will never leave.

FAIRY SEATS

✶ Depending on their size, fairies may put mushrooms to a number of uses besides living in them. They make comfortable woodland seats, and if it starts to rain, broad-capped toadstools make handy parasols. Fungi also form a large part of the fairy diet, especially the black variety called fairy butter.

Castles: The Essentials

Some fairies make their homes in human castles, living in the cellars or dark corners and occasionally helping out with the chores, rather like very grand brownies. Others are fascinated by abandoned turrets and haunt their remains, some with good and some with evil intent toward human travelers. Many fairies have their own magnificent dwellings, built in the air from clouds, or in the far north from ice. Water fairies own impressive palaces under the waves, decorated with plunder from shipwrecks. The entrance to fairy castles may be in the human realm, but hidden from sight by powerful spells.

REDCAPS

✳ Explore abandoned castles at your peril, since they are haunted by a number of evil fairies such as the Redcaps of Lowland Scotland, who attack travelers and try to re-dye their caps in the blood of their prey. When the blood dries the color disappears, so that the Redcap has to look for a succession of new victims.

CASTLES IN THE AIR

✳ Some flying fairies build castles in the air. If you look up on a fine summer's day and see white towers, you might mistake them for cumulus clouds, but you would be wrong. From their lofty battlements the fairies can gaze down on the human world below, accompanied only by birds and butterflies.

FAIRY RETAINERS

✳ Some fairies make friends with a castle's owner and join his or her retinue. In the sixteenth century a fairy called Hinzelmann lived happily in the Lüneburg Castle in northwest Germany and performed many useful services for his master in return for bread and milk. You might set your painting in a busy castle or feasting hall.

UNDERWATER PALACES

✳ The palaces of water fairies may be formed from sunken human cities, such as Atlantis, or they may build their own from crystal or coral, with windows open to the water to allow other sea creatures to swim through them. Nimue, the Lady of the Lake, raised Lancelot in her citadel under the lake.

ICE PALACES

✳ The proud and cruel Ice Queen or Snow Queen makes her home in a castle in the snowy north; it is carved from pillars of ice and glistens with frost crystals. Hers is a cold and sterile beauty, which is echoed by her environment; to love her means certain death.

GREEN LADIES

✳ Some fairies, who seem to like a gloomy atmosphere, make their homes in derelict castles covered in ivy and brambles and haunted by ravens and owls. In Scotland, for example, fairies called Green Ladies are often found in such places and sometimes disguise themselves as bunches of trailing ivy.

Mossy Stump *by Linda Ravenscroft*

The mossy tree stump on which this toadstool village is based has been developed into a face. This is the type of painting where your imagination can be combined with your observations and memories of what you may have seen in the countryside, but if you don't feel confident to make up the toadstool shapes you can use reference books. Start by making small sketches to work out the composition.

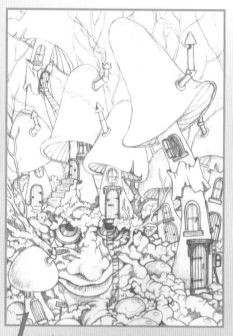

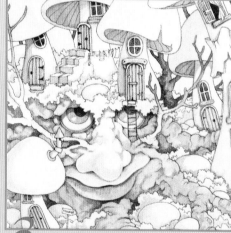

1 Referring to your sketches, draw out the image with an HB pencil. Add some pencil shading to show the face on the tree stump, but don't press too hard as you will need to erase the lines later. Indicate the moss with small wavy lines, letting some of it overlap the bottom of the toadstools so that they appear firmly rooted in the ground, not just perched on top. Put in the doors, adding details such as hinges, door knockers, and the cobweb ladder.

2 Using a waterproof sepia pen, draw around the toadstools, adding detail to the doors and windows. Reinforce the wavy lines for the moss and those around the edges of the tree stump. Do not ink in the eyes and tree stump details, as the face will look more natural if it is painted in and the lines removed with an eraser. You can make adjustments at this stage, such as shortening the stepladder in front of the face and adding a washing line.

3 Using a sepia wash and a No. 0 brush, go over the pencil shading on the tree stump, keeping the washes soft by blotting any over-wet areas with paper towels. Deepen the shadows in the eye sockets and beneath the bottom lip, and then add the shadows under the toadstools, still using the same wash color and brush. Mix some lamp black into the wash and put in the pupils and a little more shadow under the moss, then paint in the windows, using a tissue to blot up color if it is too dark.

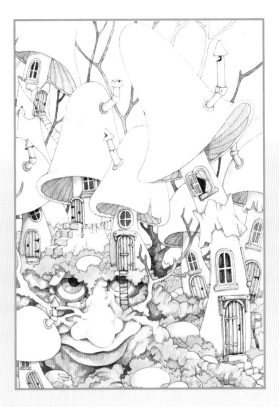

4 Using a No. 1 brush, apply a thin wash of olive green all over. This will give definition to the composition and indicate how the village will look. You can also paint in a few background twigs using a very pale wash of raw umber. Carefully remove some of the pencil lines with a soft eraser.

COLORS USED

Cadmium Yellow	Burnt Sienna
Cadmium Red	Indian Red
Purple Madder	Sepia
Viridian	Payne's Gray
Olive Green	Lamp Black
Yellow Ocher	Zinc White Gouache
Raw Umber	

5 Using masking fluid and an old No. 1 brush, mask out (see page 21) the areas where the smoke is rising from the chimneys, the highlights on the top right side of the toadstool caps, and any other areas that are to remain white. When the fluid has dried, use the wash brush to lay a wash of olive green over the whole image, starting at the top and working downward. Allow to dry.

6 Build up the color on the moss further using washes of olive green, varying the tones so that some areas are darker than others. Using a stronger wash of the same green, apply darker areas all around the edges of the background to give an impression of depth. Add a little raw umber and sepia to the dark and mid-toned areas on the face.

1 Using purple madder and a No. 4 brush, apply a wash over the top edge of each toadstool, making the tone darker on the shadow side. While still wet, apply a wash of raw umber to the bottom of the toadstool caps and allow the two colors to merge together. With burnt sienna and a No. 1 brush, add color to the doors, eyes, bottom lip, and a few chimneys. Allow to dry before painting a wash of viridian over the chimneys, leaving small areas of the original burnt sienna showing to give a rusty, weathered look. Fill in the remaining twigs and the window and door frames with a mix of raw umber and a little sepia.

8 Apply a wash of viridian to the face in the shadow areas and beneath the moss above the eyes, then use the same color to paint in the curtain. For the pebbles, mix two separate washes of Payne's gray and cadmium yellow, and work wet into wet (see page 18), dropping in cadmium yellow in the centers and Payne's gray around the edges. Use Payne's gray again for the steps and chimneys, and Indian red for the mailbox. Add more olive green to the top left corner, using small, dabbing brushstrokes.

9 Using purple madder and a No. 4 brush, wash over the tops of the toadstool caps and then add a light wash of yellow ocher to the background, around the edges of the toadstools and into the shapes between them. With a No. 1 brush and a mixture of lamp black and olive green, darken the pupils of the eyes, the inside edges of the windowframes, and the undersides of the toadstool caps. These are shaded from sunlight so need to be quite dark to give a three-dimensional look. Add a little detail to the washing using cadmium red.

10 Add a little more purple madder to the toadstool caps to warm them up and give them more emphasis. Then use a sepia pen to restore any details that have become lost. Pen drawing might be needed on the gills on the undersides of the toadstool caps, the steps, and the chimneys. Add dabs of viridian wash to the background with a No. 1 brush to increase the sense of depth. Remove the masking fluid, and tint the smoke plumes with a small amount of Payne's gray with a little cadmium red. Add highlights to the eyes, toadstools, pebbles, and window frames with zinc white gouache.

11 Take a careful look at the painting and decide what is needed to complete it. You can add further depth to the background using more olive green in the top right corner. Mix a lamp black and olive green wash and put in shadows cast by the chimneys. Add extra shading in the bottom left of the painting where shadows would naturally fall. Take care not to overwork the painting; it is wise to put it away for a while and look at it again later to make final decisions.

Index

Artists' Websites

✴ BRIGID ASHWOOD
www.ashwood-arts.com
email: info@ashwood-arts.com

✴ JULIE BAROH
www.juliebaroh.com
email: jbaroh@juliebaroh.com

✴ KRISTI BRIDGEMAN
www.kristibridgeman.com
email: kristibridge@shaw.ca

✴ AMY BROWN
www.amybrownart.com

✴ JAMES BROWNE
www.jamesbrowne.net
email: james@jamesbrowne.net

✴ WALTER BRUNEEL
www.fantasy-artists.co.uk/walter-bruneel.shtml
email: walterbruneel@hotmail.com

✴ JACQUELINE COLLEN-TARROLLY
www.toadstoolfarmart.com
email: jacqueline@toadstoolfarmart.com

✴ MEREDITH DILLMAN
www.meredithdillman.com

✴ KATE DOLAMORE
www.pencilshavings.net
email: statistic@pencilshavings.net

✴ JESSICA GALBRETH
www.fairyvisions.com
email: fairyvisions@aol.com

✴ VIRGINIA LEE
www.surreal-artist.co.uk
www.virginialee.net
email: virginialee@mwfree.net

✴ MARCEL LORANGE
www.lorange-art.com
email: webmaster@lorange-art.com

✴ MYREA PETTIT
www.fairiesworld.com
email: myrea@fairiesworld.com

✴ MELANIE PHILLIPS
www.redkitestudios.co.uk
email: office@redkitestudios.fsnet.co.uk

✴ STEPHANIE PUI-MUN LAW
www.shadowscapes.com
email: stephlaw@shadowscapes.com

✴ LINDA RAVENSCROFT
www.lindaravenscroft.com
email: linda@lindaravenscroft.com

✴ ANN MARI SJÖGREN
www.fairypaintings.com

✴ WENCHE SKJÖNDAL
http://wenche.skjondal.net
email: wencheskjondal@yahoo.se

✴ PAULINA STUCKEY
www.paulinastuckey.com
email: paulina@paulinastuckey.com

✴ KIM TURNER
http://home.austarnet.com.au/moiandkim/Default.html
email: faeriegirl@austarnet.com.au

✴ MELISSA VALDEZ
www.thegypsyfaeries.com
email: melissa@thegypsyfaeries.com

✴ LINDA VAROS
www.lindavaros.com
email: info@lindavaros.com

✴ MARIA J. WILLIAM
www.mariawilliam.net
email: maria@mariawilliam.net

✴ KATHARINA WOODWORTH
www.aquafemina.com
email: inspiratrix@aquafemina.com

Picture credits

Quarto would like to thank and acknowledge the following artists for supplying illustrations reproduced in this book:

Key: l left, r right, c center, t top, b bottom

✴ Myrea Pettit 23c, 25t, 25bl, 27, 31tc, 120c ✴ Julie Baroh 28t, 28br, 29b, 100l ✴ James Browne 16t, 26t, 31tl, 40r, 41l, 41c, 43r, 102r, 116l ✴ Marcel LorAnge 14b, 23t, 26c, 26b, 29tl, 29tr, 102c, 103c, 119r ✴ Rob Sheffield 16b, 18b, 19r, 21tr, 21bl, 23b, 28l, 30r, 31tr, 40l, 40cl, 40cr, 41r, 45l, 47r, 65l, 65r, 66l, 67c, 82c, 83c, 84l, 84r, 86l, 87l, 98l, 99l, 101t, 102l, 103l, 105c, 105r, 117c, 117r, 118l, 121l ✴ Katharina Woodworth 18t, 22l ✴ Melanie Phillips 24 ✴ Linda Ravenscroft 25br, 30t, 30l, 31cr, 41t, 42l, 42r, 43l, 46l, 62r, 63r, 64l, 64r, 66c, 67l, 67r, 83r, 84c, 85l, 85c, 86r, 87c, 98c, 100c, 101b, 104c, 105l, 116cr, 117l, 118r, 119l, 120r, 121c ✴ Kim Turner 29c, 44c ✴ Melissa Valdez 31b, 47c ✴ Amy Brown 42c, 62l, 118c, 120l ✴ Jacqueline Collen-Tarrolly 43c ✴ Olivia Rayner 44l, 44r, 45c ✴ Walter Bruneel 45r, 99r ✴ Elsa Godfrey 46c, 63l, 64c, 65c, 66r, 82l, 83l, 85r, 86c, 87r, 98r, 99c, 100r, 103r, 104r, 116cl, 121r ✴ Ann Mari Sjögren 46r ✴ Stephanie Pui-Mun Law 47l ✴ Janie Coath 62c ✴ Kate Dolamore 63c ✴ Greg Becker 82r ✴ Martin Jones 104l ✴ Veronica Aldous 119c

In addition to the above, some artists are acknowledged in the captions beside their work.

All other photographs and illustrations are the copyright of Quarto Publishing plc. While every effort has been made to credit contributors, Quarto would like to apologize should there have been any omissions or errors—and would be pleased to make the appropriate correction for future editions of the book.

AUTHOR ACKNOWLEDGEMENTS

Special thanks to the artists whose beautiful illustrations appear in the gallery sections, and to the step-by-step artists who took so much time to show, in detail, their creative techniques and painting skills. Thanks also to Per Arne Skansen for his discovery of Ann Mari Sjögren—the Swedish fairy artist, now 86 years old—whose wonderful pictures we proudly include in the gallery.

The author is indebted to Brian Froud and Wendy Froud for their extraordinary faery genius; Alan Lee, illustrator, and Marja Lee Kruÿt, visionary artist, for inspiring their daughter Virginia Lee (whose wonderful images appear in the book); Terri Windling for words of faery wisdom; Hazel Brown for her great support. Thanks also to Natalie Pierandrei, Marja Lee Kruÿt, Linda Biggs, Jasmine Becket-Griffith, and Wendy Ice, for their continued support, and Ray Danks (www.filray.co.uk) for his website work on www.fairyartists.com, www.fantasy-artists.co.uk, and www.fairiesworld.com. For use of images thanks also to Vicente Duque "The Oldest Librarian" (pp 94); Papyrus Ltd "Constellation" (pp 1, 93); Sandra Reynolds-Butler "The Sunflower Fairy" (pp 48–51).